IMAGES
of America

HOFWYL-BROADFIELD PLANTATION

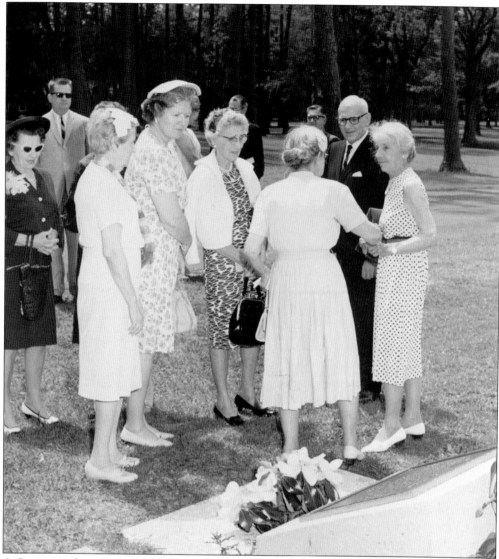

A Spirit of Sharing. In the warm sunshine of a Georgia morning in 1964, Ophelia Troup Dent, the last of five generations to live at Hofwyl-Broadfield Plantation greeted her long-standing friends and cousins at a ceremony marking the dedication of the Ophelia Dent Park at Boys Estate north of Brunswick. Located on the site of what was once Elizafield Plantation, Boys Estate, near Hofwyl, was the recipient in a series of gifting that would ultimately lead to the disposition of her ancestral property to the State of Georgia. Later Dent would remember Boys Estate in her will. Pictured from left to right are Evelyn McKinnon, unidentified, Fanny Phillips, Natalie Haynes, Birdie Paul, Mary Phillips, and Dr. Albert Galin. (Courtesy of Georgia Archives, Vanishing Georgia Collection, gly168.)

On the Cover: In 1964, Ophelia Troup Dent celebrated the dedication of the Ophelia Dent Park at Boys Estate on what was once Elizafield Plantation. Boys Estate, founded by Ardell Nation, helped give a home and structure to the lives of many boys in the area. Always a lover of swimming and the sea, Dent felt that all boys needed an old-fashioned swimming hole. (Courtesy of Georgia Archives, Vanishing Georgia Collection, gly178.)

IMAGES
of America

HOFWYL-BROADFIELD PLANTATION

Sudy Vance Leavy
in affiliation with Friends of Hofwyl

ARCADIA
PUBLISHING

Published by Arcadia Publishing
Charleston SC, Chicago IL, Portsmouth NH, San Francisco CA

Printed in the United States of America

Library of Congress Catalog Card Number: 2007934000

For all general information contact Arcadia Publishing at:
Telephone 843-853-2070
Fax 843-853-0044
E-mail sales@arcadiapublishing.com
For customer service and orders:
Toll-Free 1-888-313-2665

Visit us on the Internet at www.arcadiapublishing.com

This book is dedicated to my grandchildren in hopes that they will always maintain an interest in family and the place in which they live.

CONTENTS

ACKNOWLEDGMENTS

Always as I turn down the drive leading into Hofwyl-Broadfield Plantation, I feel as if I am entering a special world—a place where time has stopped. I marvel that one woman could live on the edge of the marsh, 10 miles from town, and delight in each day that she was there. My study of Ophelia Troup Dent has led me into her world. Wonderful happenstances have come my way as I learned more about this native Georgian. I commend the Department of Natural Resources, State Historic Sites, for their wisdom in accepting Dent's legacy and managing the property for over 30 years. My special thanks to Frankie Mewborn, head of Historic Sites and to all in the Department who have been so willing to help. Thanks goes to the staff at Hofwyl-Broadfield Plantation, to those currently working there, and those who preceded them. The partnership with the State of Georgia and the Department of Natural Resources owes thanks to the care that Albert Fendig Jr. and his father, Albert Fendig Sr., have given to their charge. They deserve credit for their love of Hofwyl and their strong feeling that Ophelia Dent's wishes should be paramount. Likewise, the Nature Conservancy in its role and support helped make Ophelia Troup Dent's wish a reality. Commendation should go to Georgia's secretary of state and the staff under whose auspices the Georgia Archives began their splendid gathering of all the photographs for the Vanishing Georgia Collection. Fortunately, all of the holdings at Hofwyl were catalogued and microfilmed by the state archives. Encountering Ophelia has been one of my greatest joys. Such a wealth of people appeared in my path. An especial thanks goes to Arabella Cleveland Young, who in her wisdom saved the correspondence between her mother, Arabella Clark Cleveland, and the Dent sisters, who were schoolmates. Fred and Sarita Marland with their love of the Georgia coast and history introduced me to Young and have provided a wealth of knowledge. My dear friend Patricia Cofer Barefoot encouraged me to tackle the project, serving as a sounding board. My friendship with Rabbi Saul Jacob Rubin and his wife, Elsie Parsons Rubin, expanded my knowledge of the family and their Savannah heritage, with its connections to some of the country's most prominent Jewish families. Locally, extended family of the Dents, Brailsfords, and Troups led by Brailsford Troup Nightingale Jr. rallied to provide information and images, as well as neighbors Dr. Joe Iannicelli at New Hope, the Alfred Joneses at Altama, and members of the Needwood Community. Many fortuitous acquaintances occurred with each museum or historical society I requested help from. The right person was there. Attribution is given to the institutions, but I would like to thank individuals: Secretary of State Karen Handel and her staff; Steven Engerrand and Gail DeLoach at Georgia Archives; Linda Bitley at the Department of Natural Resources; Nora Lewis, Georgia Historical Society; Denise Spear, Fort Frederica National Monument; Mary Ellen Brooks at Hargrett Rare Book and Manuscript Library, University of Georgia Libraries; Beth Moore, Telfair Museum of Art; Joyce Baker, Gibbes Museum of Art; John Hunter, Jekyll Island Museum; Pat Morris and staff, the Museum of Coastal History; Mimi Rogers, the Sea Island Archives; Karen Schoenewaldt, Rosenbach Library and Museum; Jonathan Harrison, the Library, St John's College, Cambridge; Matthew Bailey, National Portrait Gallery, London; and Susan Newton, Winterthur. Locally, the Brunswick News provided photographs, while Three Rivers Regional Library helped with research. Technical help came from John and Eric Toth and Rachel Lowe at the Darkroom, and local genealogist Amy Hedrick contributed much. My artist friends rallied: Mildred Wilcox, William Temple, Jeannine Cook, and Albert Fendig Jr., as well as photographic talents Cesar Ito, Kathy Stratton, and Bobby Haven. Gratitude is given to those from the past who saved emphemera: Sarah Cornelia Leavy, Margaret Davis Cate, Albert Fendig Sr., and those who shared their collections: Harriet Gilbert, and Darienites, Lloyd Young Flanders, and Billy Bolin. Appreciation is due my family and a host of friends who were always interested in the project. Ophelia Troup Dent and Miram Gratz Dent have greatly enriched my life, and the wonderful people at Arcadia Publishing made sure their story was told.

INTRODUCTION

The brick entranceway that defines Hofwyl-Broadfield Plantation today stands against a backdrop of woods, very close to the hustle and bustle of I-95, north of Brunswick, Georgia. Now a State Historic Site managed by the Department of Natural Resources, the plantation is open to visitors year round. When visitors drive into this preserve, they enter a special world—one made possible by the last of the owners of Hofwyl-Broadfield Plantation. Ophelia Troup Dent, the last of five generations to call Hofwyl-Broadfield home, bequeathed 1,268 acres of land, the main plantation house, along with furnishings and outbuildings to the State of Georgia. Yet she was giving much more than just an historic spot.

Hofwyl-Broadfield Plantation stands as a testament to the staunchness of its former owners. Records and letters reveal how each of the families loved this land. For them, their ultimate dictate was the preservation of it. To have sold it would have been a travesty to the different generations that made the plantation their home. Each surmounted obstacles to hold on to the land, feeling a responsibility not only to family members, but also to the workers who for several generations worked the land.

Hewn from the rich land lying alongside the Altamaha River, the plantation lies where the cultivation of rice was achievable. The use of tidal hydraulics made possible the flooding and draining of the rice fields. The institution of slavery provided the manpower and the knowledge of the vagaries in growing the crop. From 1807 until just before the Civil War, rice was queen and reigned as the main crop at Hofwyl-Broadfield. Three generations prospered in the production of it. The simple, low-country-style plantation house stood as a symbol of those who inherited the land, worked it, and made it prosper. The families came back to the spot, drawn to their heritage, each adding layers to the house's decor and its history.

The richness that is Hofwyl-Broadfield Plantation is a study not only of the land but also of the families. On both paternal and maternal sides, the Dents came from a long line of influential people. In each generation, the will of a strong woman often prevailed. To learn of the family is to look closely at the last surviving member—Ophelia Troup Dent. Faced with what to do with her legacy, she determined that it was a gift, one to be bequeathed so that others could visit it and learn about one of the last surviving plantations on the Georgia coast.

When the State of Georgia acquired the property in 1974, the first pamphlet spoke of the flora and fauna and focused on how the rice fields were built and how intensive the cultivation of the crop was. But the broad vista of marsh, the immense sky above, and a forest of trees underscored the uniqueness that visitors to Hofwyl-Broadfield immediately felt as they walked the grounds and interpreted for themselves the beauty and uniqueness that was Hofwyl. The bugs might be bad, but natural beauty prevailed. Likewise, the simplicity of the simple plantation house layered with furnishings from each generation created warmth. The house was not Tara; the furnishings were a mélange of hand-me-downs. Plain furnishings were juxtaposed against fine museum-quality pieces. The house simply had a lived-in feeling, and visitors responded to that simplicity. No one had to guess how the Dents would have arranged the home. All was just as they left it. The Misses Dents' world, that of Miriam and Ophelia, greeted visitors as if time had been stopped.

The buildings outside portrayed an earlier time when former slaves and their families came back to work as free people at Hofwyl after the War Between the States and settled in nearby neighborhoods. Equipment stood in the barn as a reminder of crop cultivation and the dairy days when the Dents turned to production of milk to keep the plantation afloat. Outbuildings reflected the days when workers were paid at the pay shed or when milk was bottled in a special shed. All was intact. And that perhaps is the story of Hofwyl. For in the specialness of the setting, in the simple beauty of the main house, and in the attached buildings, a unique world is

preserved. Time stopped in 1973 at Hofwyl-Broadfield, but its legacy is something that expands and is enhanced each year.

As the coast of Georgia grows and welcomes new residents and visitors to its special beauty, here is an enclave to the past. No one can walk the paths at Hofwyl, tour the home, and stand and look across the marsh without feeling the sense of place that each of its owners felt and wanted to preserve. Thankfully, Ophelia Troup Dent in the spirit of her ancestors wanted others to know the beauty of the special place they called home. Today Hofwyl-Broadfield welcomes any and all who enter its special world—a unique setting on the Georgia coast where the ocean lies only several miles away.

A SPECIAL PASSION. "I've gotten crazy over swimming and neglect all my duties at any time of day or night to run have a swim. Up till this year, I've never had any confidence, and have always been a little scared, but for some unknown reason I lost all cowardness this summer & simply *adore* it."—Ophelia Troup Dent. (Photograph by Kathy Stratton.)

One

THE GIFTING OF
HOFWYL-BROADFIELD

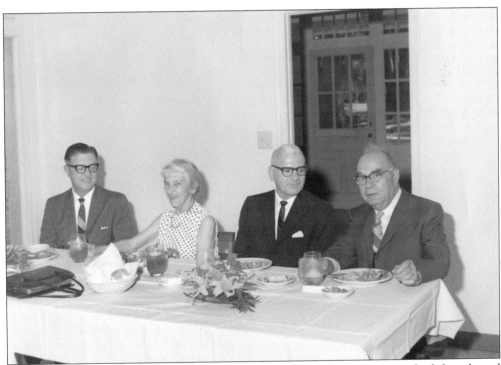

THE REALITY OF A WISH. With Ardell Nation, founder of Boys Estate, on the left and good friends Dr. Albert Galin (center) and attorney Albert Fendig (right), Ophelia Dent enjoyed the highlights of the day. The gifting of the park may have honored the memory of her two brothers: young James, who had died at four, and Gratz, the older, who was always there to guide the sisters. The gift also represented her longtime support of local charities and her concern for others. Fendig reminded those in attendance of the Dent sisters' determination during the Depression when they dutifully delivered the milk to their customers throughout the area to keep Hofwyl afloat and to support those who worked there. (Courtesy of Albert Fendig Jr.)

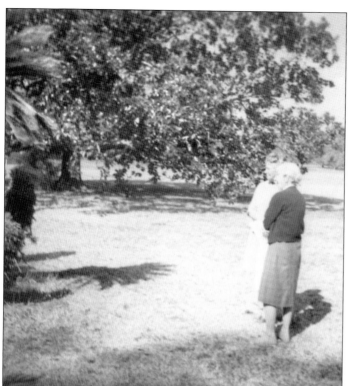

A Reflective Moment. Walking the grounds of Hofwyl in 1970, Ophelia Dent paused with a friend near a large sago palm in front of her home. Her bequeathing of Hofwyl consisted of more than just land and property, for there were all the memories associated with it of family, friends, and events and its importance as a cultural and historical site. (Courtesy of Albert Fendig Jr.)

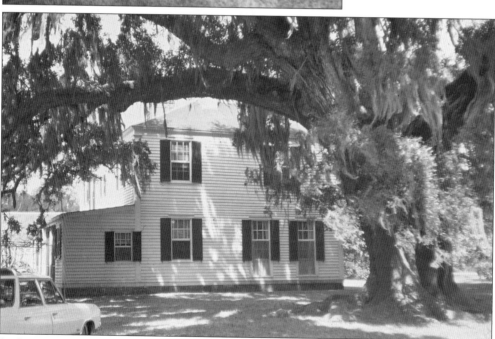

In Silent Vigil. A lone car parked at the side of the house under the spread of the limbs of one of the mighty oaks Ophelia Troup Dent loved so much stood testament to the passing of an era. The dedication of Hofwyl-Broadfield Plantation on November 20, 1974, at 2:00 p.m. signaled the beginning of yet another era. (Courtesy of Albert Fendig Jr.)

A BRIEF HISTORY. In the dedication program, several paragraphs delineated the history of Hofwyl-Broadfield Plantation. On July 1, 1975, Victoria Reeves Gunn of Atlanta completed her definitive study "Hofwyl Plantation" for the Georgia Department of National Resources, exploring many aspects of the historic site by focusing on the various families, the rice culture, and the house and its contents. (Courtesy of Albert Fendig Jr.)

HISTORY OF HOFWYL-BROADFIELD PLANTATION

Hofwyl Plantation was one of the great nineteenth century Altamaha rice plantations. Originally contained in Broadface, a King's Grant made in 1763, the land came into the hands of William Brailsford in 1807, when it was renamed Broadfield. Brailsford died in 1810 and left his wife, Maria Heyward Brailsford, and their daughter, Camilla, to manage the plantation. Camilla's marriage around 1814 to Dr. James Troup resulted in his responsibility for the family properties. Troup added an adjoining section of land called New Hope to Broadfield.

Following Troup's death in 1849 the plantation was divided. A section taken from Broadfield and possibly New Hope was a legacy to Troup's daughter, Ophelia and her husband, George Columbus Dent. Their portion was named Hofwyl in honor of the school Dent had attended in Switzerland. In 1858, Broadfield House burned and the family moved into Hofwyl House, which had been built about seven years earlier as an overseer's residence.

James T. Dent, the son of George and Ophelia Dent, acquired Broadfield, bringing both properties together. The land remained in single family ownership until the death of the last of the direct Brailsford-Troup-Dent line, Miss Ophelia Dent, in 1973.

PROGRAM

PRESIDING.............................Joe D. Tanner
Commissioner
Department of Natural Resources

INVOCATION....................Rev. Junius J. Martin
Rector of Christ Church
St. Simons

WELCOMING ADDRESS...................Jimmie Williamson
Coastal District Member
Board of Natural Resources

SPECIAL GUESTS....................Mr. William Haynes
Publisher and Historian

* * * * * *

INTRODUCTION OF PLATFORM GUESTS........Joe D. Tanner

DEDICATION ADDRESS..................Mr. Albert Fendig
Counselor of Law

ACCEPTANCE OF DEED....................Mrs. Jane Yarn
Board of Governor's
The Nature Conservancy

CLOSING REMARKS.........................Joe D. Tanner

THE DAY'S PROGRAM. The dedication brought together longtime friends, such as Bill Haynes of Darien, who operated the Ashantilly Press; the Rev. Junius J. Martin of Christ Church, Frederica; and other state dignitaries. Friend and attorney Albert Fendig depicted Ophelia Dent as the "sweetest, most gracious, and courageous lady" and reiterated her concern that Hofwyl be preserved and protected after her death. (Courtesy of Albert Fendig Jr.)

11

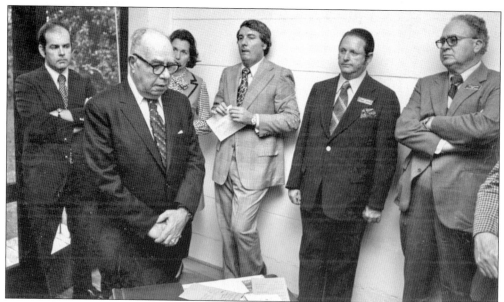

A FEW REMARKS. From left to right, James Langston, First National Bank of Brunswick; Jane Yarn of the Nature Conservancy; Joe Tanner, commissioner, the Georgia Department of Natural Resources; Mayor Jimmie Williamson of Darien; and George Dillard followed Albert Fendig's remarks. The gifting of Hofwyl included not only the house and the 1,268-acre tract but also the Dent and Troup Family Memorial Trust for maintenance of the property. (Courtesy of Albert Fendig Jr.)

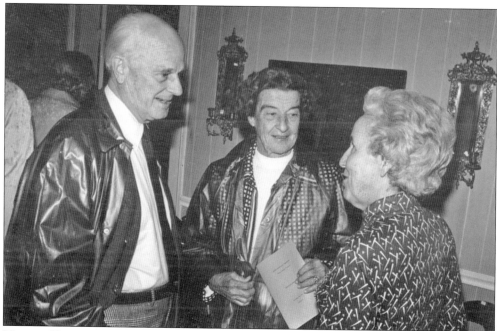

NEARBY NEIGHBORS OF ALTAMA. From left to right, Alfred Jones, president of the Sea Island Company, and his wife, Katherine, talk with Gladys Gowen Fendig. Each had special memories of "Miss Ophelia." Visitors to the home that day were free to tour the parlor, dining room, downstairs bedroom, and kitchen, opening off the central hallway. (Courtesy of Albert Fendig Jr.)

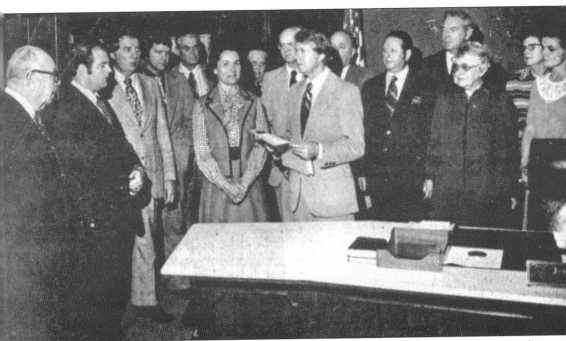

AN OFFICIAL GIFT. Then governor of Georgia and former president Jimmy Carter accepted the formal delivery of the deed for Hofwyl-Plantation to the State of Georgia at his office in Atlanta in 1974. In accepting the property, the state committed to restoring the plantation house; constructing a museum and interpretive center, along with a movie auditorium-lecture facility; and exploring the possibility of a rice-growing station. Pictured during the deed presentation are, from left to right, Albert Fendig Sr., attorney and coexecutor of Dent's estate; James Langston of the First National Bank of Brunswick, coexecutor of the estate; Joe Tanner, commissioner of the Georgia Department of Natural Resources; and in the center are Jane Yarn, member of the board of directors of the Nature Conservancy and Gov. Jimmy Carter. Others at the ceremony were members of the Department of Natural Resources Policy Making Board. (Courtesy of the *Brunswick News*.)

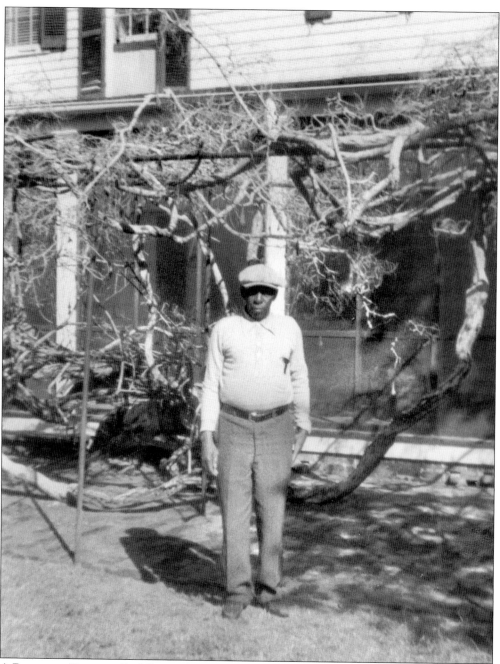

A READYING PROCESS. By fall 1978, local news stories told of ongoing work at Hofwyl-Broadfield. Guided by Dent's wishes, the state followed her dictate to use the site for "scientific, historical and aesthetic purposes." An important interpreter of her life and surroundings proved to be butler Rudolph Capers, who had worked at Hofwyl-Broadfield since the 1930s. (Courtesy of Albert Fendig Jr.)

No Change Needed. The state chose some of the finest talents available for the restoration. Norman Askins of Atlanta served as architect, and Henry Green, noted authority on antiques, assisted as well. Added improvements were a new entrance and restrooms located in the former servants' quarters. Meanwhile, the towering oaks of Hofwyl stood steady, needing no change or refurbishing. (Above courtesy of Coastal Georgia Historical Society [CGHS]; below courtesy of Bobby Haven, the *Brunswick News*.)

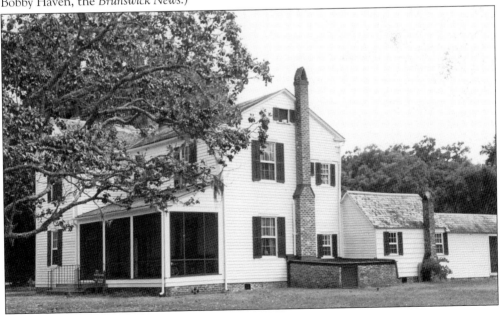

A Period Recaptured. For generations, the gates of Hofwyl had swung open to welcome friends and visitors. Those arriving on Saturday, June 2, 1979, revisited a part of coastal Georgia's past. Important to the interpretation of the site was a thorough depiction of the rice culture's period and influence, which had been forgotten. (Courtesy of CGHS.)

HOFWYL - BROADFIELD

PLANTATION

" 1807 TO THE FUTURE "

Dedication and Public Opening
SATURDAY, JUNE 2, 1979
10:30 a.m.

THE ORDER OF THE DAY. Using rice as a motif, the program for the reopening of Hofwyl-Broadfield Plantation brought together those who had worked on the project and others who could offer glimpses into the lives of those who had owned the land and those who had worked it. (Courtesy of CGHS.)

TIME CONDENSED. A "Brief History" in the program spoke of the site's past, with its passage from the cultivation of rice to dairy farming, and told of the five generations that had lived there. Also enumerated were the steps in bequeathing the land from its last owner to the State of Georgia. (Courtesy of CGHS.)

A GATHERING OF DIGNITARIES. Henry D. Struble welcomed the group, Rabbi Saul Jacob Rubin spoke of the melding of the Jewish and Protestant sides of the family, and historian Malcolm Bell Jr. addressed the importance of Hofwyl as one of the last rice plantations. Various friends shared their favorite stories about Ophelia. In closing, Rudolph Capers, with deep devotion, delivered the benediction. (Courtesy of CGHS.)

RICE AS QUEEN. The interpretive focus shared forgotten aspects of rice cultivation along the Georgia coast. A film underscored the difficulty of producing the crop. Displays using photographs from the early 1900s detailed the steps involved. A scale model of the rice fields demonstrated the checkered pattern of the fields divided by canals running between them with dikes above. (Courtesy of CGHS.)

WALKING THE TRAILS

at

HOFWYL ~ BROADFIELD PLANTATION

glynn co., georgia

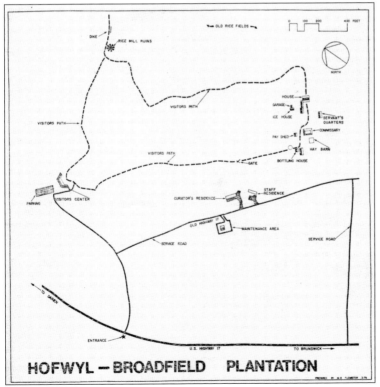

HOFWYL – BROADFIELD PLANTATION

WALKING THE FIELDS. A new road sheltered by woodlands curved from Highway 17 into the site. The quietness of the woods transported visitors back in time. From the Visitors' Center, located west of the house and outbuildings, visitors could take a path across the pasture up to the main house. (Courtesy of CGHS.)

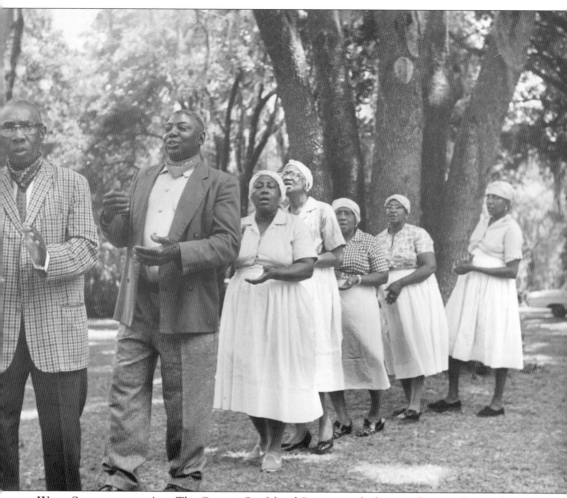

WITH SONGS IN THE AIR. The Georgia Sea Island Singers, with their renditions of songs dating back to slavery days, added to the day's jubilance and brought it to a fitting close. For years, Lydia Parrish, wife of the famed commercial artist Maxfield, spent hours at Hofwyl getting those who worked there to sing for her so that she might transcribe the words to the songs. Handed down for generations, many of the songs dated back to Africa and chronicled the daily lives and chores of the slaves. When Parrish published *Slave Songs of the Georgia Sea Islands* in 1942, she acknowledged "the Misses Dents, of Hofwyl Plantation on the mainland in Glynn County" for helping preserve the songs. The singers, pictured from left to right, are George Cohen, Jerry Harris, Rosalee White, Leola Harris, Emma Lott, Josephine Bennett, and Ruth Cohen. Both the Cohens and Harris received bequests from Dent's will. (Courtesy of Georgia Archives, Vanishing Georgia Collection, gly187.)

Two

LINEAGE AND ANCESTRY

WITH BRIGHT-EYED ASSURANCE. Always Ophelia Troup Dent looked straight into the camera's eye. Though small in stature, she possessed exuberance and confidence from each of her parents and her progenitors. Known for his steadfastness, her great-great uncle was Georgia's fiery governor George Michael Troup (1823–1827). She too displayed courage and determination, whether facing a rattlesnake or diligently managing Hofwyl's accounts. Through various generations, not only were there strong men but women also. Many of her later actions would mirror the charities of her great-great aunt Rebecca Gratz. The Ophelia for whom she was named marched her family and those they owned to safety inland during the Civil War. Afterward, she returned to help rebuild a plantation that had lain fallow for four years and enable the free people who returned to Hofwyl to buy land and settle at Petersville. This same kindness would be evidenced in the regard that Dent had for those who had worked at Hofwyl or aided the family. (Courtesy of Georgia Archives, Vanishing Georgia Collection, gly169).

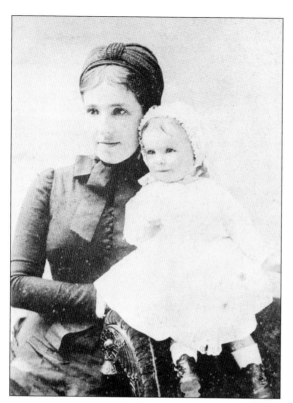

THE LOVE OF A MOTHER. Miriam Gratz Cohen Dent cradles one of her babies. Born into an established Savannah family, she likewise possessed spirit and determination that would allow her to be equally as comfortable in Savannah society as on a plantation on the Altamaha Delta. The mother of four, she would lose her young son James to diphtheria. (Courtesy of Georgia Archives, Vanishing Georgia Collection, gly220.)

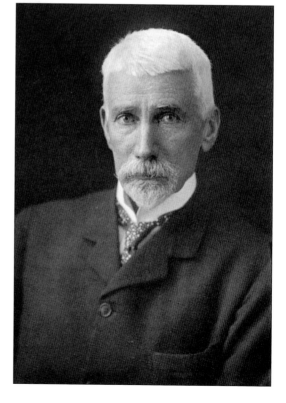

THE INFLUENCE OF A KIND FATHER. Possessing an inherited love of the land, James Troup Dent instilled this same love in his children. From an early age, they came to Hofwyl. Until 1903, the family did not spend the night there. At that time, Dent wisely installed screens to ward off the danger of malaria from mosquitoes. (Courtesy of Georgia Archives, Vanishing Georgia Collection, gly173.)

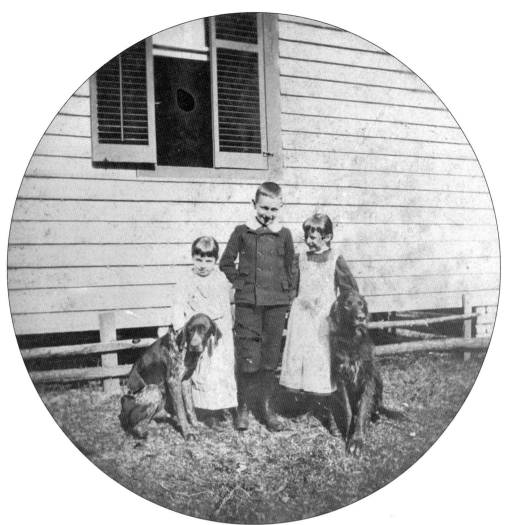

THE CLOSENESS OF SIBLINGS. The Dent children, flanked by their ever-present dogs, paused outside the house at Hofwyl in the 1890s. Pictured from left to right are Ophelia, Gratz, and Miriam. Growing up in downtown Savannah, the children loved the freedom that staying at Hofwyl offered. Here they would return throughout their early adulthood. Later the girls and their mother would make it their home permanently after their father's death in 1913. As remote as Hofwyl was, many friends and visitors would find their way there throughout the years. After the deaths of their mother in 1931 and their brother Gratz in 1932, the Misses Dents continued to reside there and were the last of five generations to call Hofwyl home. The immediate family line had ended. (Courtesy of Georgia Archives, Vanishing Georgia Collection, gly216.)

Brailsford, Troup and Dent Lineage

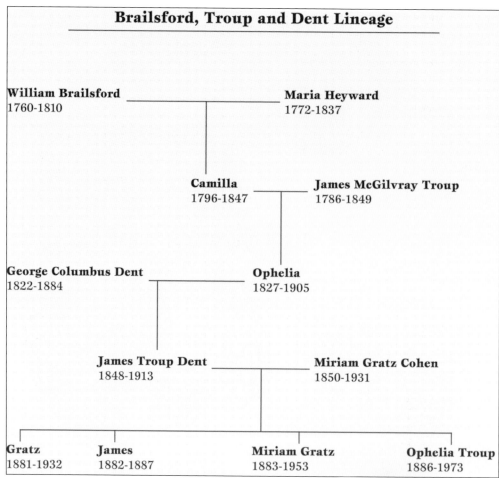

William Brailsford
1760-1810

Maria Heyward
1772-1837

Camilla
1796-1847

James McGilvray Troup
1786-1849

George Columbus Dent
1822-1884

Ophelia
1827-1905

James Troup Dent
1848-1913

Miriam Gratz Cohen
1850-1931

Gratz
1881-1932

James
1882-1887

Miriam Gratz
1883-1953

Ophelia Troup
1886-1973

ONE FAMILY TREE. With his English father, Samuel, who had emigrated from England in 1714, William Brailsford enjoyed both the education of a continental experience in Europe and the bustle of the growing seaport town of Charleston. His mother, Susan Holmes, was the daughter of provincial governor Joseph Morton of the Royal Province of South Carolina. William married Maria Heyward. He sought land along the rich crescent of the Altamaha River and established plantations there. In her unpublished memoirs, *c.* 1902, Ophelia Troup Dent would record many of her remembrances of her grandfather. She also noted that the first case of the U.S. Supreme Court was *Samuel Brailsford vs. James Spalding.* Samuel Brailsford (right) was the great-great-great grandfather of Ophelia Troup Dent. (Family tree courtesy of Watermarks Printing; photograph courtesy of Kathy Stratton.)

24

THE MANY BRANCHES. Genealogy and family pride in ancestors were inherent with the Dents. The ephemera saved by various generations of Dents were handed down from one to the other just as the furniture and silver were. Working on a piece of Sea Island stationery, Ophelia or Miriam labored to record the various Dent ancestors. (Courtesy of the Georgia Department of Natural Resources, Hofwyl-Broadfield Plantation State Historic Site.)

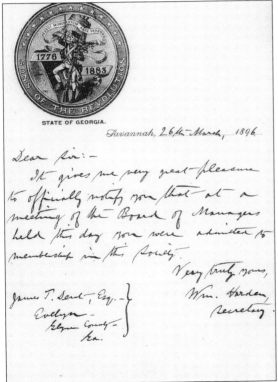

REVOLUTIONARY SERVICE. James Dent had seen military service during the War Between the States, when at age 15, he marched off to war with his father, George Columbus Dent. Both returned home safely. His interest in family history was natural. In 1896, he was accepted as a member of the Sons of the Revolution. (Courtesy of the Georgia Department of Natural Resources, Hofwyl-Broadfield Plantation State Historic Site.)

MASTER OF HIS FATE. With an exuberant expression, James Troup Dent readied for a trip to Hofwyl. In the late 1800s, to travel from Savannah to Darien, McIntosh County, was arduous. Train service was slow in arriving to the coast of Georgia because of the various rivers that emptied into the sea at Darien. (Courtesy of the Georgia Department of Natural Resources, Hofwyl-Broadfield Plantation State Historic Site.)

A SAFE DELIVERY. Battalion orders from Capt. Joseph Manigault issued for young Private Dent and William P. Couper from St. Simons Island to report to Savannah indicates that most coastal families were acquaintances. Following the War Between the States, Dent and relatives, such as Charles Spalding Wylly, who had served in the war, recounted their experiences. (Courtesy of George Columbus Dent Collection MS 213, item 2, Georgia Historical Society, Savannah, Georgia.)

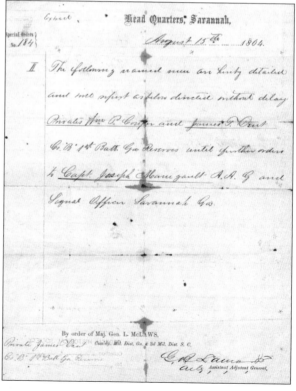

MISTRESS OF THE HOUSE. The portrait by Jeremiah Theus of Susan Elizabeth (Holmes) Brailsford of Charleston underscores the social position of the Brailsfords. Theus's talent was in great demand throughout the coastal cities. Once, this portrait hung at Hofwyl; it was later bequeathed to a cousin in Savannah by Ophelia Dent. Dent noted in her will, "The Brailsfords were the original owners of Hofwyl." (Courtesy of William Boston McKinnon Jr.)

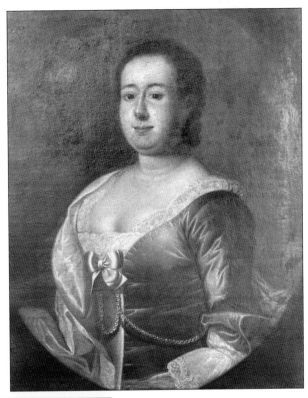

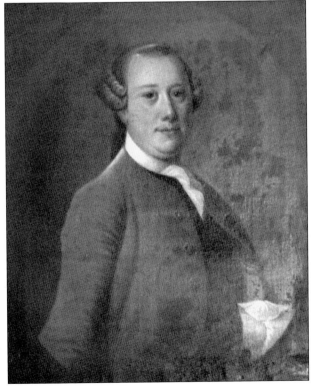

AND THE MASTER. Another portrait by Theus of Col. Samuel Brailsford, whom grandmother Ophelia Troup Dent referenced in her memoirs, descended to other family members. After a hurricane on Broughton Island, the family moved from Charleston to the island; then William Brailsford received a king's grant to Broadface on the mainland, felled the first trees there, and called it "Broadfield." (Courtesy of Brailsford Troup Nigthingale Jr.)

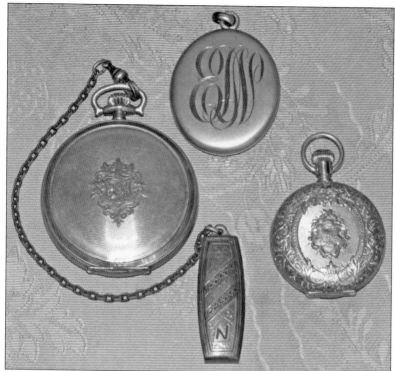

TIME PASSED. A gold pocket watch and locket whose fineness of detail depicts the work of a master craftsman are favorite items of a Troup descendant. Handed down in the family as heirlooms, they survive as testimony to the uniting of families, their correspondent businesses, and their unique histories. (Courtesy of Brailsford Troup Nightingale Jr.)

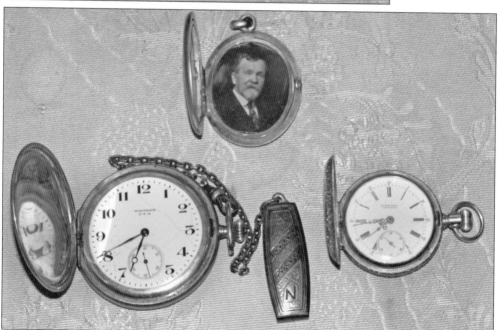

TIME PASSING. Sentimental items like these connect to a family's history perhaps even more than a signature in a book. By the passing of the item to the next generation, family bonds remained linked. The pocket watches belonged to the Dents' cousins Phineas Miller Nightingale and his wife, Ethel Downing Nightingale. (Courtesy of Brailsford Troup Nightingale Jr.)

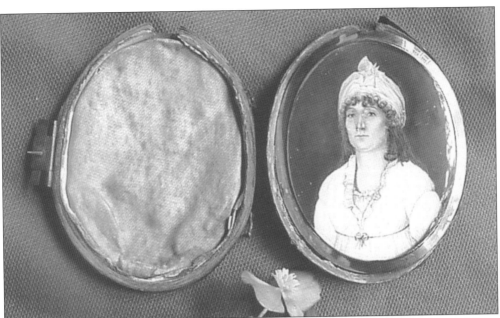

A SURVIVOR. Miniatures capturing a loved one's likeness could be carried by an admirer. Those rendered by famous artists were very desirable. Amazingly, this particular miniature survived. Found in a dumpster near Brunswick by an antique picker, Camilla Brailsford's likeness was saved. The daughter of William Brailsford, she married Dr. James Troup at Maj. Jacob Wood's summer home at the Ridge in 1813. (Courtesy of Randy Lee Marshall.)

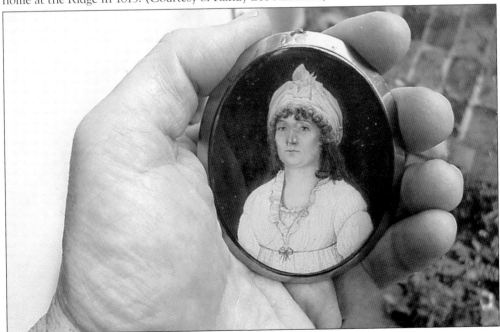

THE ART OF THE MINIATURE. Often a locket of hair might be placed inside the miniature. Watercolor was favored as a medium, and the painting was often done on ivory. Amazingly Camilla Brailsford's delicate features survive along with a depiction of the fashionable headdress of the day. (Courtesy of Randy Lee Marshall.)

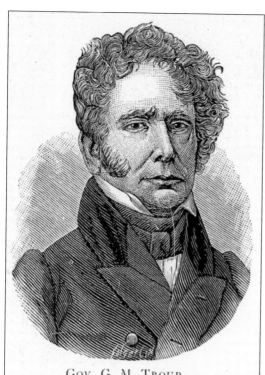

Gov. G. M. Troup.

A STATE LEADER. Another hand-drawn genealogical chart done by a family member traces the Troup line. Ophelia Dent's great-grandfather James McGilvray Troup was Governor Troup's brother. Her great-great grandfather George Troup came from England, married Catherine McIntosh, and worked as a bookkeeper for McKay and Spalding on St. Simons Island. A card table and four chairs at Hofwyl came into the family from Gov. George Troup, who is pictured. (Courtesy of Brailsford Troup Nightingale Jr.)

LAND AT ISSUE. Dr. James McGilvray Troup's estate required almost a decade to settle. He requested that none of the property at Broadfield be sold to pay debts. Daniel Heyward Brailsford Troup and neighbor James Hamilton Couper of Hopeton and Altama served as executors of the estate. Issued in 1858, this lien indicated real estate taxes due on the estate. (Courtesy of the Georgia Department of Natural Resources, Hofwyl-Broadfield Plantation State Historic Site.)

STATE OF GEORGIA,
CITY OF DARIEN.

To the Marshal of said City---Greeting :

WHEREAS, by the Tax Ordinance of said City it is ordained, that the Treasurer shall proceed by distress and sale against all persons who shall be in default in the payment of the Taxes imposed by said Ordinance or Ordinances. These are therefore, in the name of the City, to command you, that of the goods and chattels, lands and tenements of *Estate James Troup*

you do levy or cause to be levied the sum of *Twenty five dollars*

being the amount of *Real Estate tax*

for said City, for the year Eighteen Hundred and *Fifty Eight* and to sell the same, or so much thereof, as shall be of sufficient value to satisfy said claim, with the cost and charges thereon, to the highest bidder, at public out-cry, before the Court House of said City, giving due and legal notice of such sale. And for so doing, this shall be your warrant.

GIVEN under my hand and seal of Office, this the *10th* day of *October* Eighteen Hundred and *Fifty Eight*

L. E. B. D. Lamo CITY TREASURER.

Elizafila 29 March 1832

Received of D. H. B. Troup Exr of Dr James Troup $40,62/100 for Salary to the Clergman of St Davids Church

Hugh Fraser Grant
Treasurer,

OBLIGATIONS MET. Dr. Troup's estate was large—7,300 acres, two tabby houses, one wooden house, and 357 slaves. A payment to the clergy was just another obligation to be met. The division of the estate occurred in 1858. The northern part of New Hope became the property of Ophelia Troup and her husband, George Columbus Dent. (Courtesy of the Georgia Department of Natural Resources, Hofwyl-Broadfield Plantation State Historic Site.)

IN THE SOLEMNITY OF A PASTURE.
Located near Eulonia, a large, broad
field today serves as a cattle pasture.
Disturbed in recent years, Baillie's
Cemetery is a mélange of tumbled
markers, marble slabs, and broken
ironwork. Here was the burial site for
several infants; Charles Morris and
his wife, Hannah; her mother, Maria
Brailsford; the D. H. B. Troups; and Dr.
James and Camilla Troup. (Photograph
by the author.)

MEMORIES

BY

Charles Spalding Wylly

1 9 1 6

RECORDED MEMORIES. On the coast
of Georgia and throughout the state,
war, natural disasters. and the passing
of time effaced much history. The rare,
recorded memories of individuals are a
rich resource. Charles Spalding Wylly
even noted how his grandfather tied
a cravat. Related to the Troups, Wylly
touched on the broad history of the area
and recorded rice production. (Courtesy
of Sarah Cornelia Leavy.)

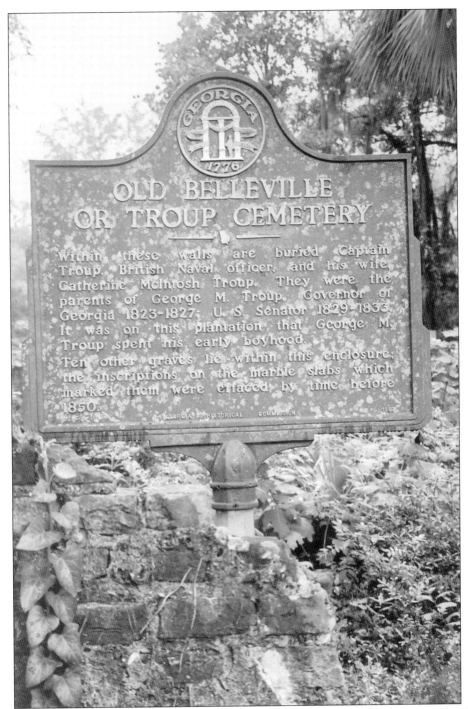

BROKEN WALLS. Neither the graves nor the splendid William Jay home located at Cathead in Darien survives to tell the story of George and Catherine McIntosh Troup. Marked by a state historic marker, the McIntosh vault overlooks the Sapelo River. Family history tells of a summer home at Baisden's Bluff and of an artesian well with the coldest of water located near the river. (Photograph by the author.)

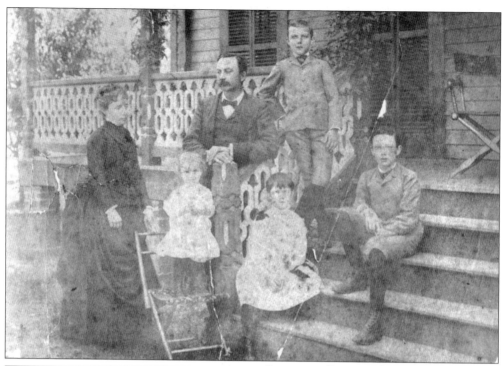

THE DOWNING CO.

C. DOWNING, PRES'T. ALBERT FENDIG, V. PRES'T. J. J. CONOLEY, SEC'TY C. P. DUSENBURY, TREAS.

Brunswick, Ga. June 24, 192_

Dear Mother,

I wrote you two letters and I put a letter for Downing in one of yours.

Please put my watch on my dresser so I can get it in the morning. Phenia said to night that I have been as good as I could be while you have been gone.

Kiss me when you come if I am asleep.

Thanks for the telegram.

Love
Brailsford

EXTENDED FAMILY. The Troup offspring multiplied. One granddaughter married a descendant of Francis Scott Key; another, Oralie, was cited for her beauty by Fanny Kemble. Minnie, daughter of D. H. B. Troup, married John Nightingale. Nightingale family members, pictured *c.* 1884 from left to right, are John A. K. Nightingale; his wife, Maria Heyward Troup; with children Phineas Miller Nightingale (standing); Brailsford Troup Nightingale (sitting); Maude Nightingale; and Mary. (Courtesy of Brailsford Troup Nightingale Jr.)

SAVED MOMENTS. Saving a letter written by a young boy to his mother documents not only a child's love but also a family business. The Downing Company, associated with the timber industry, dealt in naval stores at the Brunswick Waterfront, after the production of rice and cotton ended. Many descendants of the named officers on the letterhead still live in the area today. (Courtesy of Brailsford Troup Nightingale Jr.)

A Moment's Rest. Miriam and James Dent pause on the steps of a home possibly in the south end of Brunswick in the early 1900s. The Nightingale home, located in the south end, fronts on one of the many squares modeled after those in Savannah. Cousins visited often on a given Sunday and stayed the afternoon. (Courtesy of Georgia Archives, Vanishing Georgia Collection, gly 221.)

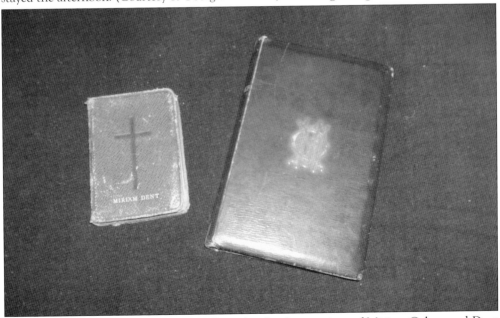

Melding of Religions. In the James Dent family, the marriage of Miriam Cohen and Dent united not only two families but also the duality of religions. Miriam Dent, daughter of Solomon Cohen of Savannah, was reared in Temple Mickve Israel. Dent was an Episcopalian. The families melded their religions, as the placement of prayer books—one Jewish and one Episcopal—in the living room at Hofwyl suggests. (Photograph by Kathy Stratton.)

IMPORTANCE OF FAMILY. Pictured in the 1850s in Savannah, the Solomon Cohen family shows Miriam Gratz with her mother and father and siblings Belle and Gratz. Belle also would marry outside the Jewish faith, choosing Frank O'Driscoll, who lived just down the street. On the back of this photograph, Miriam Dent detailed who was to receive it. (Courtesy of Georgia Archives, Vanishing Georgia Collection, ctm229.)

THE OTHER HOME. Given to James and Miriam Dent as a wedding gift from her father, the house on West Liberty served as the Dent home until the early 1930s. All the children were born there. Cousins and friends lived nearby, and their grandparents, the Cohens, were just up the street. The Cohen house stood in the block now occupied by the Savannah Civic Center. (Courtesy of Rabbi Saul Jacob Rubin.)

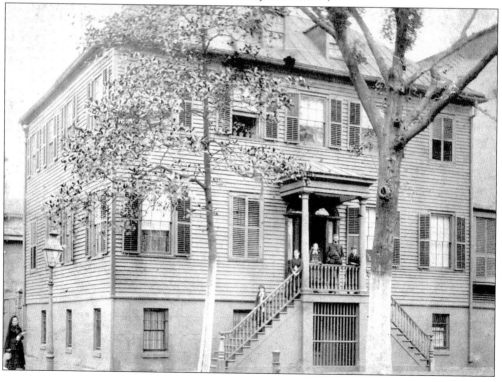

SCION OF THE CITY. Coming from Georgetown, South Carolina, Solomon Cohen entered into all aspects of commerce in pre–Civil War Savannah. Admitted to the bar, active in railroading and banking, and committed to Temple Mickve Israel, Cohen served the city he loved. He was postmaster for two presidential terms and elected to Congress. His prewar allegiance negated his acceptance. (Courtesy of Georgia Archives, Vanishing Georgia Collection, ctm 227.)

ON THIS CORNERSTONE. A program saved by Cohen's daughter Belle O'Driscoll commemorates the new synagogue's dedication on Monterey Square. Like Charleston, the Jewish population was integral to the city's cultural richness. A group of 42 Hebrews arrived in Savannah in 1733. The majority were refugees of the Sephardic tradition. They brought their Torah and willingly established their roots, contributing greatly to the young city. (Courtesy of Rabbi Saul Jacob Rubin.)

EULOGY
ON THE
LIFE AND CHARACTER
OF THE
Rt. Rev. Stephen Elliott, D. D.,
BISHOP OF THE DIOCESE OF GEORGIA,
AND
PRESIDENT OF THE GEORGIA HISTORICAL SOCIETY.
BY
HON. SOLOMON COHEN.

Written and Published at the Request
OF THE
GEORGIA HISTORICAL SOCIETY.

SAVANNAH:
PURSE & SON, PRINTERS,
MDCCCLXVII.

AN OUTSTANDING FRIEND. Solomon Cohen spoke in honor of his friend the Reverend Stephen Elliott at the Georgia Historical Society. Episcopalian and Jew, devoted friends in a city where the families of different faiths comingled, the two men shared a friendship over a period of many years. Cohen also served as vice president and curator of the society. Elliott was president of the society and was the first Episcopal bishop of Georgia. (Courtesy of Rabbi Saul Jacob Rubin.)

A TREASURED LETTER. Solomon Cohen came from a tradition of letter writing. To take pen to paper and express feelings to a daughter offers an additional insight into the character of Ophelia Troup Dent's maternal grandfather. Cohen eloquently closed the letter to her Aunt Belle with the following: "I can write no more at present. Love to Frank—all good angels guard you both." (Courtesy of Rabbi Saul Jacob Rubin.)

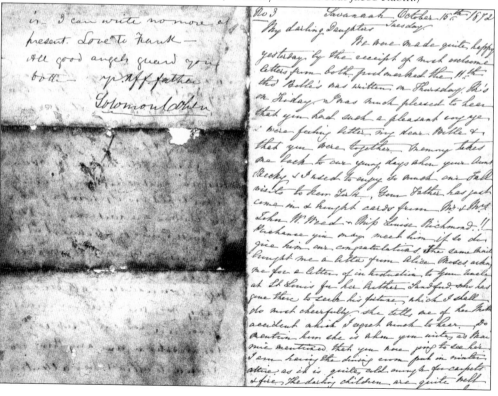

TRIBUTE OF RESPECT. Drafted by the faculty of the Savannah Medical College, this tribute listed Solomon Cohen's contributions to the group during his lifetime. On August 19, 1875, another statement of regret on Cohen's death appeared in the *Savannah News*. The Bar of Savannah, who had attended his funeral "in body," drafted it. Describing his character, the group noted "his high-toned and inflexible integrity." (Courtesy of Rabbi Saul Jacob Rubin.)

TO LEAN UPON. This cane, preserved at Hofwyl and held dear by Solomon Cohen's granddaughters, was given in honor of his 50 years of service to the temple. Another accolade from the Meeting of the Bar recorded, "He always manifested a keen interest in all that concerned the welfare of Savannah and his fellow citizens." His life exemplified service. (Photograph by the author.)

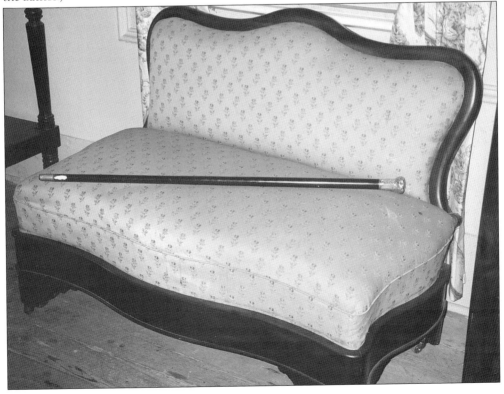

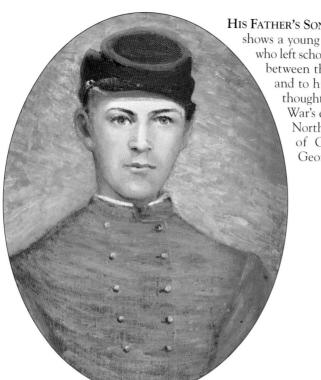

HIS FATHER'S SON. Gratz Cohen's picture at Hofwyl shows a young man in his Confederate uniform who left school to join in "the disastrous conflict between the sections." Letters to the family and to his aunt Rebecca Gratz express his thoughts. Sadly, he died close to the Civil War's end at the battle of Bentonville in North Carolina, March 1865. (Courtesy of Georgia Archives, Vanishing Georgia Collection, gly222.)

Headquarters Local Battalion,

September 16th 1864.

Gratz Cohen

You are hereby enrolled in Co. H. Local Battalion, and will report as such to the Captain of said Company as soon as the same is organized.

By order of

Lieut. Col. John Screven, Commanding.

R. H. Woodbridge
Adjutant.

CALLED TO DUTY. What a compression of a life this simple order to battle records. The only son of Solomon Cohen, Gratz Cohen held such promise to follow in his father's path. Sadly, he was one among many not to return home. (Courtesy of Rabbi Saul Jacob Rubin.)

BEYOND THE GATE. The Jewish section of Laurel Grove Cemetery in Savannah bears witness to early Savannah history. The Cohen plot links families and their stories. The monument to patriarchal head Solomon Cohen towers behind the delicate design on the gate of a weeping child. Just to the left, simple slabs mark the graves of the Dents—parents, sisters, and brothers. (Photograph by Cesar Ito.)

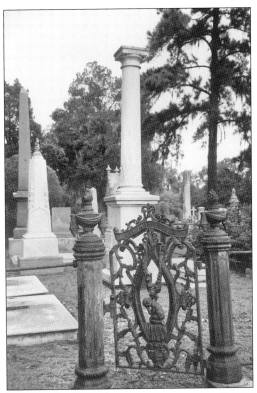

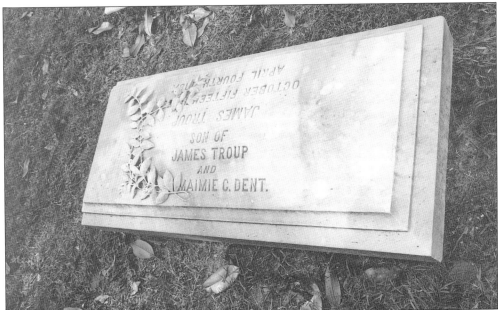

LESS WE FORGET. The young boy James Troup Dent, his father's namesake, merited an ornamented coffer. In her will, his sister Ophelia specified an amount for Laurel Grove for the cleaning of the family tombstones in perpetuity. She also noted that she desired to be buried next to her father, whose grave is marked CSA, as is that of her grandfather's Solomon Cohen. (Photograph by Cesar Ito.)

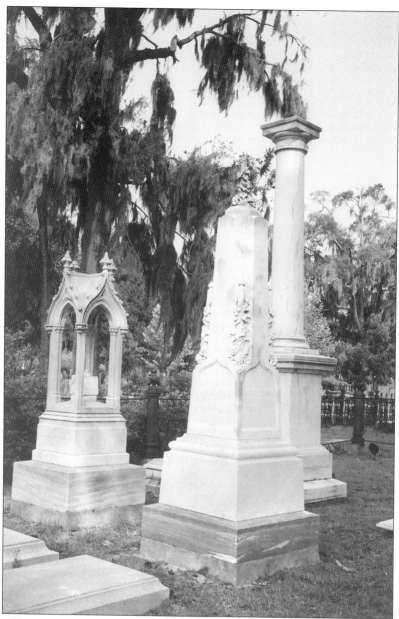

RECORDED HISTORY. The brevity of a monument's concise wording records a person's entire life. This trio depicts father, son Gratz, and Solomon's brother Octavius. The beauty of the carvings reflects a lost art and harkens to a time when the size and splendor of the mason's art captured the prosperity of the deceased. But more important than monumental show is the tracing of the kinship of those enclosed within the plot. Cousins who were always close rest together. A father who was Episcopalian lies next to his Jewish wife and their children. Grandparents and great-grandparents, those who lived well past three score and 10, and those who lived but for a short while comingle. When urban sprawl and progress have effaced homes, the simplicity and beauty of a cemetery offer a respite. Towering obelisks compete with tall, straight pines, while moss-draped oaks shadow the brightness of the white marble. In the ever-bustling city of Savannah, this site holds some stories recorded only at the grave. (Photograph by Cesar Ito.)

A Remembering. For the 1979 dedication and public opening of Hofwyl-Broadfield Plantation, Rabbi Saul Jacob Rubin, Temple Mickve Israel of Savannah, gave the invocation. Newly arrived from Richmond, Rabbi Rubin officiated at the burial of Ophelia Troup Dent in 1973 in Laurel Grove Cemetery. Through the years, his interest in her and her family grew as he met the various members both Jewish and Protestant. In his invocation, Rubin captured the duality of the families' religious worship and acquainted those there with the lineage of the Moseses, Cohens, and Gratzes, lesser known to those in attendance than that of the Troups and Dents. For such was the incredible blending of Hofwyl-Broadfield . . . not just the land but also the families and their histories. (Courtesy of Rabbi Saul Jacob Rubin.)

congregation mickve israel
Established 1733
20 East Gordon Street
Savannah, Georgia 31401

Saul J. Rubin
RABBI

I DID CONSULT WITH PATTY DEVEAU BEFORE EXTENDING THE INVOCATION WITH A FEW COMMENTS. A DEDICATION AT SUCH A HISTORIC SITE ASSURES US THAT A RICHER ORIENTATION TOWARD LIFE IS ASSURED WHEN ONE HAS A SENSE OF CONNECTION TO THE PAST. WE OUGHT TO BE AWARE WE ARE STANDING ON SOIL CULTIVATED BY SOME OF GEORGIA'S EARLIEST SETTLERS. THESE TREES HAVE STOOD SILENT VIGIL AS GENERATIONS HAVE COME AND GONE. THE BRAILSFORDS, THE TROUPS, THE HORRYS, THE DENTS. THAT DISTINGUISHED FAMILY WHOSE NAMES MOST GEORGIANS RESPOND TO. IT IS MEET THAT A SECOND FAMILY GROUPING BE SPOKEN OF THAT BLENDED WITH THE FIRST - - THE MOSES, THE GRATZES, THE COHENS. ISAAC MOSES, THE PROGENITOR OF THOSE WHO LAST RESIDED IN THIS HOUSE, WAS ONE OF PHILADELPHIA'S MOST PROMINENT MER-CHANTS, A FOUNDER OF ITS FIRST SYNAGOGUE, MIKVE ISRAEL, ITS CHIEF OFFICER WHEN IT ADDRESSED A LETTER OF CONGRATULATIONS TO GEORGE WASHINGTON ON THE OCCASION OF HIS INAUGURATION AS FIRST PRESIDENT OF THESE UNITED STATES. FINANCIAL AID FOR THE CONDUCT OF THE REVOLUTIONARY WAR WAS FREELY AND LIBERALLY GIVEN BY THE MOSES FAMILY... BEYOND THE MEASURE THEY COULD EASILY ENDURE. THE GRATZES OF PHILADELPHIA WERE RECOGNIZED AS ITS FIRST JEWISH CITIZENS. THOMAS JEFFERSON WROTE THE DECLARATION OF INDEPENDENCE IN A SECOND STORY BUILDING THAT HOUSED THE GRATZ'S BUSINESS ENTERPRISE. HYMAN GRATZ WILLED HIS ESTATE TO THE FOUNDING OF THE FIRST JEWISH UNIVERSITY IN AMERICA, GRATZ COLLEGE... STILL AN OUTSTANDING ACADEMIC INSTITUTION. REBECCA GRATZ WAS A

congregation mickve israel
Established 1733
20 East Gordon Street
Savannah, Georgia 31401

Saul J. Rubin
RABBI

FAVORITE SUBJECT OF GILBERT STUART AND THOMAS SULLY. AS WAS HER SISTER, RACHEL, GREAT GRANDMOTHER OF HOFWYL'S MIRIAM AND OPHELIA. SIR WALTER SCOTT MODELED HIS HEROINE REBECCA IN IVANHOE AFTER REBECCA GRATZ. MIRIAM AND OPHELIA'S GRANDFATHER WAS ONE OF SAVANNAH'S LEADING CITIZENS, THE HONORABLE SOLOMON COHEN, DESCENDED FROM A COLONIAL SOUTH CAROLINA FAMILY. IT WAS HIS BROTHER OCTAVUS WHO SUSTAINED MRS. JEFFERSON DAVIS WHILE HER HUSBAND LANGUISHED IN A FORT MONROE PRISON AFTER THE WAR. WHAT TOUCHING LETTERS SHE WROTE HIM. THEY ARE NOW HOUSED IN THE VALENTINE MUSEUM IN RICHMOND.

OPHELIA AND MIRIAM WERE EXCEEDINGLY PROUD OF THIS HERITAGE. THE LIVING ROOM AND DINING ROOM DISPLAY PORTRAITS AND MINIATURES AND PHOTOGRAPHS OF THE MOSES'S, THE COHENS, THE GRATZES.

REMEMBRANCES OF TWO GREAT AMERICAN FAMILIES ARE CAUGHT UP IN THIS HOME AND IN THESE MAGNIFICENT SURROUNDINGS. TO KNOW OF THE PAST, IS TO BE GIVEN A SENSE OF WONDER AS ONE ROAMS THIS BEAUTIFUL TERRAIN.

WE PRAY THAT, AS LAND AND HOUSE ARE DEDICATED TO THE PEOPLE OF GEORGIA AND VISITORS FROM WHENCE THEY MAY EVER COME, THAT LEARNING WILL PROCEED FROM HERE...LEARNING ABOUT THE PAST. MAY ALL BE UPLIFTED BY THE RAW SPLENDOR OF THE LIVING THINGS THAT OUR GOD HATH CREATED HERE, AND THE HANDSOME AND HISTORIC THINGS THAT THE HANDS OF MAN HAVE WROUGHT. AMEN.

A Retelling. The guestbook for the 1979 ceremony lists friends from everywhere. A Troup from New York, a Polite from Needwood, a Barrow from Savannah, and a McGarvey from Brunswick attended, along with many others. Several years later, Robby Flanders interviewed his grandfather Robert A. Young Jr. for the Frederica Academy's publication *Ebb Tide* in June 1981. Young remembered the day: "Oh, listen, the rabbi helped dedicate that property over there. . . . The rabbi made his talks and he carried Mrs. Dent's family back to the Gratzes who owned the building where they signed the Declaration of Independence. They were renting it from them. They were Jewish people." (Invocation courtesy of Rabbi Saul Jacob Rubin; interview courtesy of Lloyd Young Flanders.)

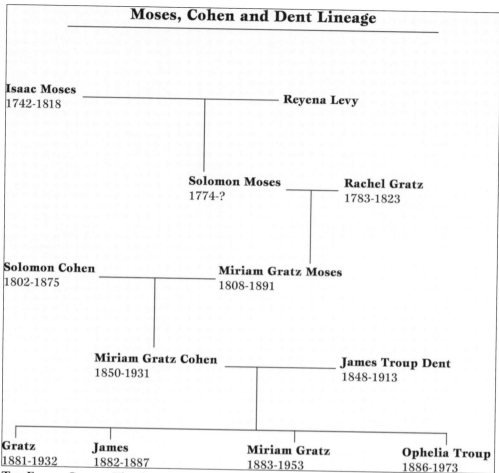

Moses, Cohen and Dent Lineage

Isaac Moses
1742-1818 — Reyena Levy

Solomon Moses — Rachel Gratz
1774-? 1783-1823

Solomon Cohen — Miriam Gratz Moses
1802-1875 1808-1891

Miriam Gratz Cohen — James Troup Dent
1850-1931 1848-1913

Gratz | James | Miriam Gratz | Ophelia Troup
1881-1932 | 1882-1887 | 1883-1953 | 1886-1973

THE FAMILY CIRCLE. The charting of the Moses, Gratz, and Cohen families can prove daunting. With a multitude of children, cousins who married cousins, and families spread across the country, Arabella Cleveland of Chadds Ford, Pennsylvania, attempted a lineage chart under the direction of Ophelia Dent in 1972. The hand-ruled chart consisting of some dozen or so pages is included in the records of the Hofwyl Archives. Descendants of these families and those of her father's would be among those remembered when Ophelia Dent dictated her 18-page "Last Will and Testament" in 1970. Her sister Miriam shared this same interest in the family's history. Their good friend William Haynes of Darien took Miriam's recounting of her grandmother's oral history and published a book in 1966 entitled *McIntosh County Georgia*. (Family tree courtesy of Watermarks Printing.)

A GREAT CONTRIBUTION. The American Revolution's success relied on financing that was willingly given from one segment of its population. The Jewish brotherhood of New York and Philadelphia helped finance the revolution. In the papers of various Moses and Gratz descendants, clippings from news articles dating as early as 1912 relate the retelling of these contributions by their ancestors. (Courtesy of Rabbi Saul Jacob Rubin.)

JEWS WHO HELPED MAKE AMERICA
By MADISON C. PETERS
ISAAC MOSES,
Coworker with Robert Morris in Behalf of the Government Finances and Through Whose Influence Specific Duties Were Levied and Custom-Houses Established.

ISAAC MOSES of Philadelphia and New York, a coworker with Robert Morris on behalf of the Government's finances and who contributed frequently to the Colonial Treasury, was one of the most sterling patriots of the Revolution. He left for Philadelphia when New York City fell into the hands of the British, returning after the war.

In Philadelphia, with Robert Morris and other patriots, he helped to launch the first bank in the United States. He gave his bond for $15,000 to make up a total of $1,500,000 in order to support the credit of the bank, which was established for procuring a supply of provisions to keep together the army of the United States. The amount of the bond was never called for, but it is well to keep in remembrance the names of those who in those times that tried men's souls stepped forward and pledged their worldly goods towards the support of those who were fighting liberty's cause.

In 1784 Moses was one of the 30 New York merchants who addressed a memorial to the State Legislature in favor of taking steps to improve the public credit and securities. The Legislature ordered that the duties be levied under a specific lien of an ad valorem tax, as recommended by the Chamber of Commerce, and Isaac Moses so worded the petition of the Chamber of Commerce that the Legislature, November 18, 1784, passed an act levying specific duties and establishing a Custom-House on the same day.

Not only was Moses one of the financiers of the American Revolution and stanch patriot, but he was distinguished as a Free Mason, and during his residence in Philadelphia became the founder of the Mickve Israel Congregation and its first presiding officer.

He purchased ground for the synagogue near the German Reformed Church, professed Christians, who immediately expressed their displeasure at having a Jewish neighbor.

Moses replied: "That we may understand each other and prevent any future differences we now offer you again the same. Our intention was to build a synagogue and schoolhouse thereon for the use of our congregation, not conceiving that we would, in the least disturb you. To our great surprise we are told that it will. We can now supply ourselves with another lot, not so convenient for our purpose, nor on such good terms, for it will cost more, but as we wish to live in friendship with our neighbors and in order to convince you that such is our meaning, we are willing to take (from you) the same price as we gave for this place."

The site selected was on the north side of Cherry street near Third. Probably the offer was accepted, because soon after the site was selected for a permanent synagogue.

It is strange that so many of the Colonists who fought so bravely for religious liberty, so often became opponents of that complete religious liberty which now lies at the foundation of American in-...tion.

Madison C. Peters.
C. Mishkin, N. Y.

(C. Peters.)

DIRECTOR OF ARCHIVES: JACOB R. MARCUS, Ph. D.
Milton and Hattie Kutz Distinguished Service Professor of American Jewish History,
Hebrew Union College-Jewish Institute of Religion

AMERICAN JEWISH ARCHIVES
CLIFTON AVENUE · CINCINNATI, OHIO 45220

April 20, 1979

Rabbi Saul J. Rubin
Congregation Mickve Israel
20 East Gordon Street
Savannah, Georgia 31401

Dear Saul:

Thank you very much for your lovely detailed note telling us about your visit to Hofwyl.

You will be interested in knowing that the miniature of Rachel Gratz Moses is known and reproductions have been made. It is said to be owned by a Mrs. John Hunter; this was years ago.

We will be delighted to receive the documents which you are going to send us, the pictures, etc.

With all good wishes and with many thanks for all your efforts, I am

Very cordially yours,

Jacob R. Marcus

JRM/rr

THE BEGINNING OF A QUEST. Always a scholar with interest both in the history of the Southern Jewish experience and of the Civil War, Rabbi Saul Jacob Rubin appreciated the melding of Protestant and Jewish families he found in the coastal city of Savannah. In his correspondence with leading scholars of the church, he shared his growing knowledge of the Dent and Cohen families. (Courtesy of Rabbi Saul Jacob Rubin.)

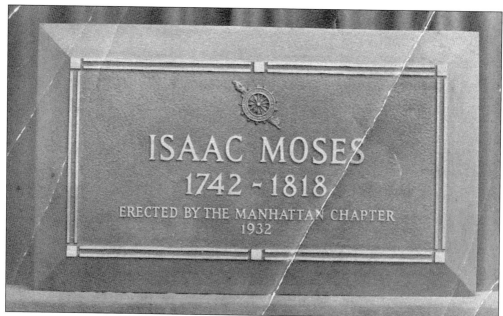

HIS GIFT AND HONOR. DAR membership denotes a contribution to the American Revolution. Issac Moses, arriving in America in 1759, underwrote credit for a bank to be established for furnishing a supply of provisions for the U.S. Army. Family records also record that John Jacob Astor was paid $1 a day for work in beating furs in the employment of the Moseses. (Courtesy of Rabbi Saul Jacob Rubin.)

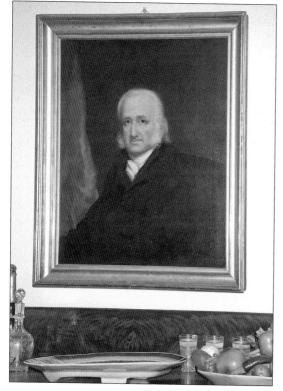

IN HIS PRESENCE. Ophelia Dent left the outstanding portrait of Isaac Moses, by John Wesley Jarvis, hanging in the dining room. A copied letter dated 1817 from family papers offered birthday wishes and a toast to Dent's grandmother Miriam. "God Bless her, may she live to a good old age" from an "Affectionate Grand Father," signed Isaac Moses. (Photograph by author; Letter, Courtesy of Rabbi Saul Jacob Rubin.)

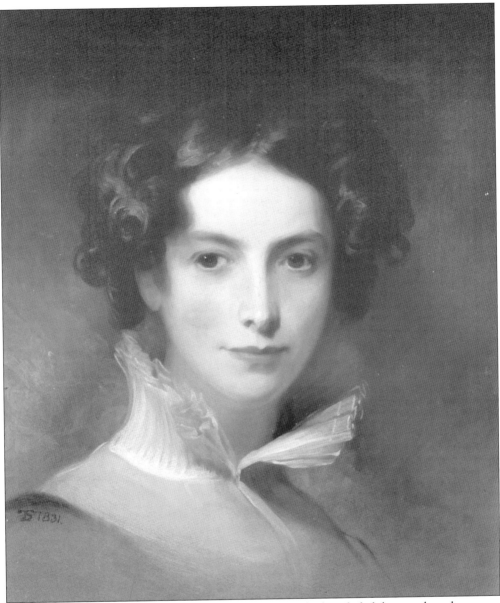

THE FAMILY BEAUTY. The Dents cherished their lineage, which included the comely and generous Rebecca Gratz of Philadelphia. A cousin, Jeanne Hunter of Savannah, indicated that this portrait by Thomas Sully was Ophelia's favorite of the artists that captured the spirit and likeness of her great-great aunt. Gilbert Stuart painted both Gratz sisters, Rachel and Rebecca. Called "first among Jewesses," Rebecca's religion shaped her personality, life, and character. At the age of 21, she was secretary of Philadelphia's Female Society for the Relief of Women and Children in Reduced Circumstances. The founder of the Philadelphia Orphan society, she served as secretary for the group for 40 years. Her love of children was obvious. With no adieu, she undertook the rearing of her beloved sister Rachel's children. Always interested in various cousins, nephews, and nieces, her letters have been collated and printed and reveal the intensity of her feeling for her family. Known not only for charitable works but for her intelligence, she knew both Henry Clay and Washington Irving. (Courtesy of the Rosenbach Museum and Library, Philadelphia.)

A LIBERATED WOMAN. Choosing not to marry, Rebecca Gratz occupied her long life with various charitable endeavors. One accomplishment was the establishment of the first Jewish Sunday school to promulgate the teaching of the temple. Growing up with a father and uncle who had myriad business interests, her acumen in various pursuits had to have been influenced by the richness of her family background. (Courtesy of Rabbi Saul Jacob Rubin.)

RECOGNITION OF TALENT. A saved invitation chronicled the dedication of a garden in memory of Rebecca Gratz in Cleveland, Ohio. Likewise, a residence hall for women erected at the University of Pennsylvania in the late 1940s, would recognize famous Philadelphia women. The inclusion of Gratz in this group was for her service to the community. (Courtesy of Rabbi Saul Jacob Rubin.)

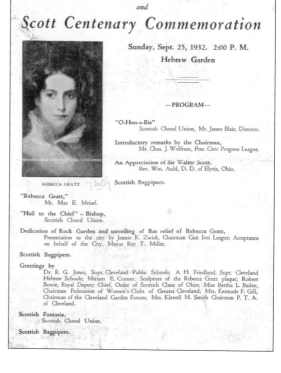

DEVOTED SPACE. In the rounded letters of a sister's handwriting, the inscribed name Rebecca Gratz destined the saving of this magazine. Appreciating the talents of Gratz, the sisters in their pursuits were influenced by her model. Ophelia Dent's bequests to many different individuals had to have had a basis in the eleemosynary endeavors of Gratz. (Courtesy of the Georgia Department of Natural Resources, Hofwyl-Broadfield Plantation State Historic Site.)

Rebecca Gratz

DAUGHTERS
of the
AMERICAN REVOLUTION MAGAZINE

VOLUME 60 NUMBER 4

APRIL
1926

The Philadelphia Conference
of
Jewish Women's Organizations
cordially invites you to attend
the unveiling of a memorial plaque
honoring
Rebecca Gratz
on the Ninetieth Anniversary of her death
Thursday morning, August twenty-seventh
nineteen hundred and fifty-nine
at ten forty-five o'clock
Mikveh Israel Cemetery
Spruce Street, between Eighth and Ninth
Philadelphia, Pennsylvania

THE CELEBRATION. Perhaps the quest to serve that Rebecca Gratz demonstrated in her endeavors was prompted by the time in which she lived. In the new nation, which was evolving, women's roles may not have been as restrictive. Gratz traveled far to visit with family and friends. Her social status accorded privilege. Then, too, her letters revealed an independence of spirit. (Courtesy of Rabbi Saul Jacob Rubin.)

49

The WELLSPRING

A WEEKLY PAPER FOR YOUNG PEOPLE

Vol. LXXI.　　　　　CHICAGO, NOVEMBER 16, 1924　　　　　No. 46

Illustration by Henry Pitz

REBECCA OF QUAKER TOWN
By Katherine D. Cather

THROUGH the velvet twilight of an April evening, a carriage crunched over the gravel of a wide, maple-lined driveway that led to an old manor house in Philadelphia. A girl, fingering the keys of a spinet, as the piano of a hundred years ago was called, heard the sound of the wheels and the thudding hoofs above the melody she was playing, and ran to the door expectantly. She was slender and supple in figure, with a rich, splendid beauty suggestive of the Orient or the tropics. As the carriage halted below the portico and a young man sprang from it, a light of pleasure came into her expressive, dark eyes, and she skipped down the steps to meet him.

"Exactly on the stroke of seven," he exclaimed as he caught the proffered hand in greeting. "It's a long and merry evening we shall have."

The girl smiled at him. He was handsome both of face and figure, and his eager, gray eyes seemed to be wells of hope and dreams. Eyes of remarkable lustre, intelligence, and restlessness they were, as if to heights of aspiration were too exalted for the spirit behind them to scale. He was dressed in the height of gentlemanly fashion of his day, in a dove-colored frock coat and trousers, embroidered waistcoat, blue satin collar and cravat. Both his attire and his equipage showed him to be a person of means and position.

"Are you ready to drive back with me in the carriage?" he asked.

Rebecca Gratz shook her head.

"It's a real grief to me to have to tell you, Washington Irving," she replied, "but things have come about in such a way that I cannot go."

THE young man looked at her with a puzzled expression.

"Cannot go," he repeated. "Surely you don't mean that. For more than a week we've been planning for and looking forward to this evening."

Rebecca nodded.

"I know," she spoke in a voice that was like a rich contralto, "for the last few days it seems I've thought of nothing else. But Sigrid needs me and I must stay with her."

Keen disappointment was in Irving's eyes.

"Is not Miriam here?" he asked. "Often I have heard you say she is a most excellent nurse. Without doubt her help will be all that still be needed."

"It isn't the nursing that matters," Rebecca objected. "It is the child's dream. When I brought her here this morning I promised to keep her until she is strong again. She thought that meant I would be with her all the time. Mother and Miriam seem like strangers to her, and when for a moment she thought I would go away and leave her, she wept piteously. I want to hear your squibs more than I can tell you, but I cannot put sadness into the life of this child who has known so little of pleasant things. I must give up the idea of the party and stay at home with her."

FOR a moment Washington Irving did not answer. One could never find fault with anything Rebecca Gratz did, he thought, no matter what keen disappointment came the decision of hers might bring. She seemed different from all other girls, all she knew as to action by some wholesome inner power. This was not the first time, nor the second, that she had given up a long-anticipated pleasure because she believed she was needed by somebody, and always she did it in such calm contentment that it was a wonderment to him. His cousins and some of the other maidens he knew occasionally sacrificed a good time to duty, but when they did they let it be known unmistakably that they deemed themselves abused or deserving of praise. But Rebecca never did. "I must do it," was all she ever said. Yet the young man knew that no girl anywhere loved pleasure more whole-heartedly than she loved it. She was an inexhaustible well of enthusiasm for everything that was part of youth.

That was what puzzled Irving so. He realized that, with her fondness for life and merriment it cost her much to set aside her own desires.

Looking at her in the fading light, and seeing the calm purpose in her face, he nodded as if he understood.

"It is like you to give up the party for Sigrid, and of course I am disappointed; but if you feel you must it is all right with you."

He went out into the pungent evening, and Rebecca watched him drive away. As her eyes followed him through the garden and into the highroad she thought of the dreams he cherished, and those his friends cherished for him, for all who knew him believed the future held golden days for him. His father, a cultured Englishman from the Orkneys, who had settled in the colony of New York when quite a young man, wanted his son to enter one of the "gentlemanly professions," so medicine, law, and the ministry were called. Not so, desired young Washington, but, to please his parent, he began a course of training in a lawyer's office. He was a diligent and brilliant student, but his heart was not among codes and codicils, and the longer he carried on his studies the more certain he was it never would be. He wanted to write, to say to the world the things he felt, thought and dreamed, and for almost four years he had been writing, contributing to the "Morning Chronicle," squibs and verses about books and people. Because of their excellent literary style and original, vigorous thought, these created a great deal of attention. But only by a few intimate friends was it known that Washington Irving was the person who wrote them, for the very excellent reason that they appeared under the pseudonym of "Jonathan Oldstyle."

Rebecca was the closest girl friend young Washington possessed. Although he did not live in Philadelphia, he visited there very often, and seldom did a fortnight pass that they were not together. He took his manuscripts to her to read before he sent them to the "Chronicle," and time after time when she exclaimed, "I believe you have splendid gifts, Washington Irving. Keep on writing as steadily and hard as you can," it was the encouragement and belief in him he had kept on and on.

That is why he was so disappointed when she told him she must stay at home with Sigrid.

There was to be a party this evening at the house of Gilbert Willing, the friend he usually visited when he came down from New York, and the entertainment planned was for him to read some of the work he had lately done.

"I want you above all others to be there," he had said to Rebecca a week before when he told her about it, "because you have such a deft wit. No matter what the others say about my squibs, if your opinion is favorable, I know I shall not need to be ashamed to let them go into print."

The idea of the party had seemed charming to the girl, and until a few minutes before Washington came for her she had expected to

Copyright, 1924, by The Pilgrim Press

attend it. Then little Sigrid Berger cried at the thought of her going away, and, too, warm-hearted to grieve the child, she set aside her evening of pleasure.

Sigrid was an orphan, the child of a Scandinavian saddle-maker who had died some six months before and was followed by his wife in less than a week, leaving three children to be distributed among whoever could take them. Sympathetic neighbors gathered in the orphaned flock and did the best they could for them, but these families were all so poor they had hardly enough food to go around before the Bergers came. Now a larger number of mouths meant smaller portions to go into each, and the result was that the entire brood was underfed and undernourished. Nobody in the Quaker city knew this any better than Rebecca, for she had a genius for discovering the troubles of the poor and contriving ways to lighten them. Several times each week she took a basket of provisions from her own plentifully stocked kitchen to help out those who sheltered the brood, and this morning, on her errand, she found Sigrid, the youngest, sick. Consequently she had brought the waif back with her to try to build up the hardship-weakened body.

IT WAS a great event to any child in Philadelphia to be taken home by Rebecca Gratz. The children of the rich delighted to be with her, for she had a marvelous stock of stories, and they regarded her as a magician who could always produce tarts and cookies. No small loss or pain ever left her home empty-handed, for no matter how many cakes and sweetmeats could be had in his own quarters, those that came from Rebecca's hands always seemed a little more delicious. But especially was this dark-eyed maiden with the deep, melodious voice adored by the children of the poor, who regarded her as a fairy princess and entertained each other with yarns of the castle-like house in which she lived and the vast wealth by which she was surrounded. And the tales were not wholly mythical. Rebecca Gratz was the daughter of one of the richest men of America, and it was an endless type of romance about the Quaker town that, although the wealth of her father enabled her to spend her days in a ceaseless round of gaiety, she gave the greater portion of them to benevolent work. Yet nothing she did amazed those who knew her, any more than it amazed Washington Irving when she set aside pleasure for duty, for to them she seemed apart and different from everybody else. The daughter of a Jew, she was a social favorite with both Jews and Gentiles, and her popularity rested on a foundation broader and deeper than her money. She was splendidly educated. She was without a peer in Philadelphia in knowledge of languages, literature, and mathematics, or in skill in performing on the spinet. Her beauty was so remarkable that the citizens of two paces, the exuberant, generous heart that never failed to respond to a human appeal.

THREE weeks passed. Then, on a shining June morning when the Quaker city seemed set for a carnival, with its gardens and pasture plots resplendent with early summer flowers, a young Kentuckian came to call. His name was Henry Clay. He was based in his own State for the eloquence of his oratory and his brilliant legal mind, and recently had been chosen to fill a seat in the United States Senate. On several occasions before being sent to the Senate he had visited Philadelphia for the transaction of legal business, and during one of these visits made the acquaintance of the Hebrew girl. He was strongly drawn to her, admiring her intellect, beauty, and social graces as much as he respected her benevolent and high-principled nature. Now that he was stationed in Washington, whenever duty permitted him to leave the capital, he never lost an opportunity

A MODEL FOR ALL. Rebecca Gratz's life was multifaceted. The recorded facts are glossed with those of legend. This saved paper from 1924 chronicles many of the stories, and retelling them introduced young readers to an influential model. Gratz was a friend of Washington Irving. This account suggests that Irving read his rendition of the *Legend of Sleepy Hollow* with only the light of one candle to an assembled group of friends including Henry Clay, Rebecca Gratz, and Gibert Willing in the parlor of the Gratz home. Another story that Gratz herself did not deny or corroborate was that heroine Rebecca in *Ivanhoe* by Sir Walter Scott was modeled after her. Legend holds that it was Irving who told Scott of his dear friend, of her remarkable beauty, her brilliant intellect, and her ardent devotion to philanthropic work. A work in 1997 by Dianne Ashton, *Women and Judaism in Antebellum America* offers an in-depth study of the Dent's famous and influential ancestress. (Courtesy of Rabbi Saul Jacob Rubin.)

Three

THE LAND

THE VAST EXPANSE. James Troup Dent was always comfortable in the saddle, according to his friend Charles Spalding Wylly. Spalding credited him with "manliness, and gentleness; simplicity and polish of demeanor; generosity of hand, and, rarer, generosity of thought." Wylly felt that the love of the land kept Dent from other pursuits where he could have excelled. Yet he noted that Dent had an instinctive love of "horse, rod, and gun." He was then a man who found pleasure in riding across the dikes of the rice field, surveying the crop he was trying to grow, and being willing to gamble on a crop that became increasingly more difficult to produce. At Hofwyl, Dent struggled up until his death in 1913, to make his crop. Labor, machinery, the vagaries of weather, and imported rice from Japan were factors that brought an end to the era of rice production on the Georgia coast. (Courtesy of Georgia Archives, Vanishing Georgia Collection, gly219.)

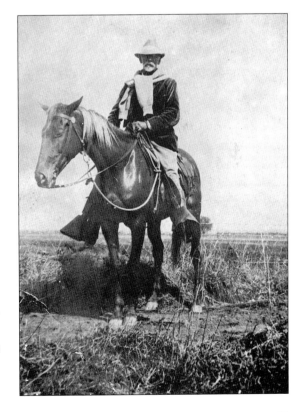

51

A Desire for Land. Georgia, the last of the original colonies, would offer land to a class of yeoman farmers. No slavery, no rum, and no lawyers were additional prescriptives. However, South Carolinians, valuing coastal land for rice production, looked hungrily south across the Savannah River and down the Georgia coast. In 1763, Henry Laurens received a royal crown grant for 3,000 acres. (Courtesy of Dr. Joe Iannicelli.)

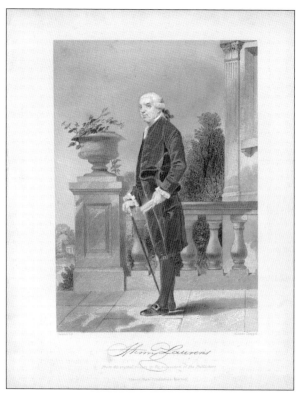

The King's Pleasure. Laurens, one of the richest and most successful American colonists, served as second president of the Continental Congress. His grant from King George III was for land "situate to the Southward of the Alatamaha River bounded on the North East by the said River and Broughton Island and on all other sides by vacant land." He called his plantation New Hope. (Courtesy of Dr. Joe Iannicelli.)

THE LAY OF THE LAND. Rice production hinged not only on intensive labor but also on the land's proximity to the ebb and flow of the tide. Clearing a strip a mile long, laying out the rice fields, and timing the water flow demonstrated an unbelievable engineering feat for the 1800s. (Courtesy National Park Service, Fort Frederica National Monument, Georgia Historical Society, the Margaret Davis Cate Collection, 997.)

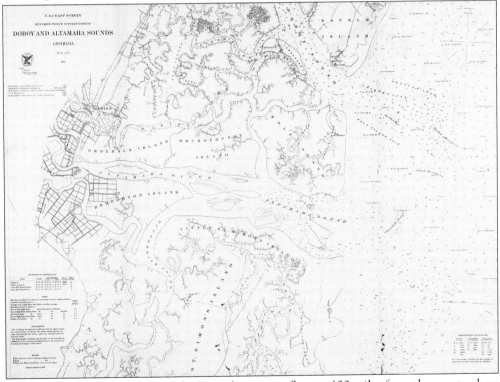

THE GREAT RIVER. The Altamaha River has its confluence 100 miles from the coast, where three rivers, the Ohoopee, Ocmulgee, and the Oconee converge. Carrying rich topsoil from the interior, mixing it with the sediment of tidal land, and depositing it on the banks, the river offered ideal rice growing conditions. The various islands, which fringed the mainland, became plantation settlements. The Brailsfords first grew rice on Broughton Island. (Courtesy of Hargrett Rare Book and Manuscript Library, University of Georgia Libraries.)

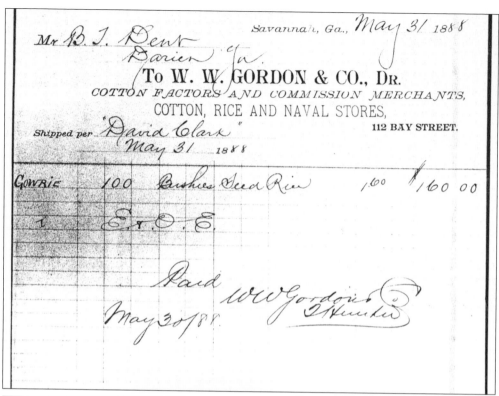

Mr B. J. Dent
Darien, Ga.

Savannah, Ga., May 31 1888

To W. W. GORDON & CO., Dr.

COTTON FACTORS AND COMMISSION MERCHANTS,

COTTON, RICE AND NAVAL STORES,

112 BAY STREET.

Shipped per "David Clark"
May 31 1888

GOWRIE	100	Bushels Seed Rice	1.60	160 00
1	E. & O. E.			

Paid
May 30/88

W W Gordon
J Hunter

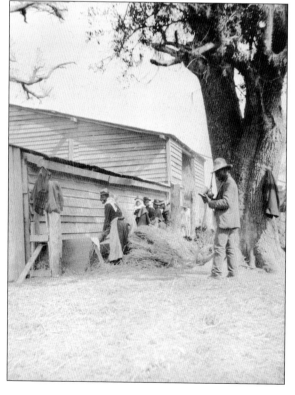

RECORDED RECEIPT. In the late 1800s, the coastal rice growers of McIntosh and Glynn Counties formed an association to protect their diminishing crop. Rules and minutes were kept. Both James Dent and brother Brailsford Troup Dent were active in the group. "Gowrie" may indicate the individual squares where the rice was grown. (Courtesy of the Georgia Department of Natural Resources, Hofwyl-Broadfield Plantation State Historic Site.)

WINNOWING AND THRASHING. With the arrival of the timber boom on the coast of Georgia, manpower was at a premium. The process of rice growing was still very much hands-on, even with the advent of more advanced machinery. Higher pay scales at the timber mills lured workers from the rice fields, but the women continued to plant. (Courtesy of Georgia Archives, Vanishing Georgia Collection , gly214.)

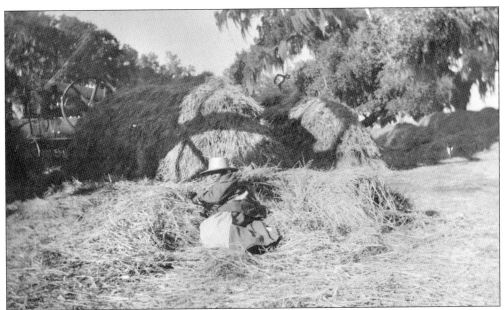

AT REST. Pictured 1910, a worker at Hofwyl pauses for the camera. The traditions of rice planting were passed from generation to generation. Planters relied on the knowledge of rice growing that slaves brought with them from the coast of Africa. (Courtesy of Georgia Archives, Vanishing Georgia Collection, gly206.)

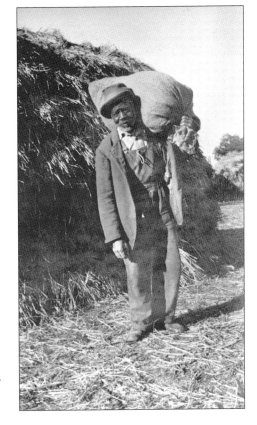

ANOTHER BAG. Rice sheaves bagged, a Hofwyl worker shoulders his load. Those who continued to work at Hofwyl lived nearby in the communities of Petersville, Needwood, and Freedom's Rest. Descendants of these families still live just off Highway 17 adjacent to Hofwyl. (Courtesy of Georgia Archives, Vanishing Georgia Collection, gly207.)

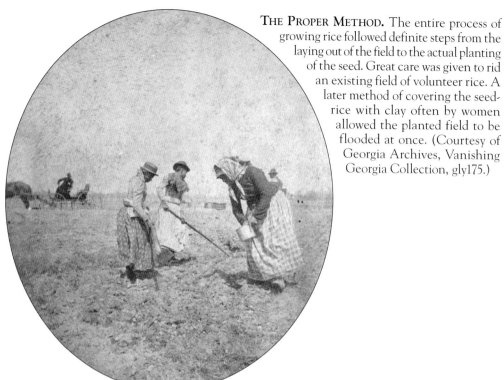

THE PROPER METHOD. The entire process of growing rice followed definite steps from the laying out of the field to the actual planting of the seed. Great care was given to rid an existing field of volunteer rice. A later method of covering the seed-rice with clay often by women allowed the planted field to be flooded at once. (Courtesy of Georgia Archives, Vanishing Georgia Collection, gly175.)

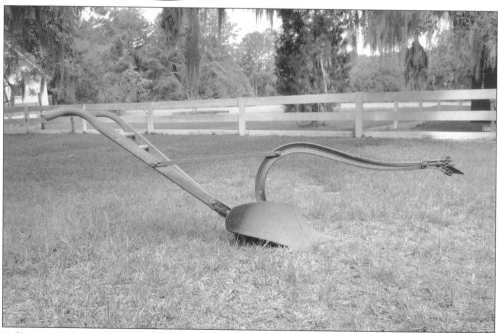

A FARMING AID. A plow still in the barn at Hofwyl was probably introduced to the plantation in the mid-1850s. It represents progress and serves as a reminder that much of the cultivation of the land and the clearing of the cypress swamps in the late 1700s was done entirely by hand before the advent of machinery. (Photograph by Kathy Stratton.)

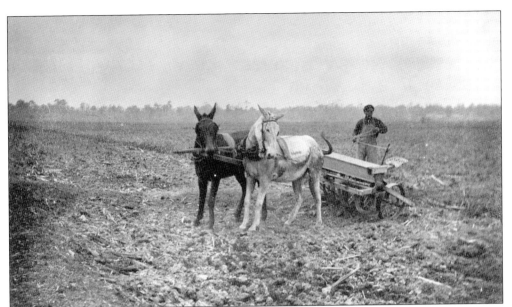

ADDITIONAL MACHINERY. With fewer laborers, a team of mules could accomplish what once would have taken many workers. Although mechanization was expedient, the dikes themselves could support only so much heavy equipment. Later further mechanization of rice cultivation and development of fields in Arkansas and Mississippi brought a close to rice production on the Georgia coast. (Courtesy of Georgia Archives, Vanishing Georgia Collection, gly 194.)

A RELIC FROM THE PAST. An example of an early thresher illustrates how rice could be grown on a small scale using simple equipment. The production of rice in the 1850s before the Civil War boomed because of actual threshing mills usually built near the waterway. The product was shipped to Savannah or Charleston for the final steps in the production cycle. (Photograph by Kathy Stratton.)

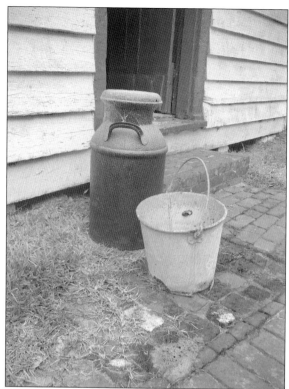

THE NEXT ERA. A milk can and bucket represent Hofwyl's dairy days. James Dent's death in 1913 signaled an end to any attempt to continue to grow rice. Brother Gratz, schooled in agriculture at Yale and working in Savannah with the County Extension Service, helped the sisters start a dairy. The success of the dairy for over 20 years bolstered the plantation's financial security. (Photograph by Kathy Stratton.)

	Dairy				House			Plantation			
	Labor	Feed	Supplies	Ice	Wages	Groc.	Supp	Wages	Supplies	auto	
Jan	157.90	358.15	8.75		93.6.	29.45	29.22	126.41	57.54	14.70	
Feb	157.60	55.00	23.65		89.25	36.52	26.42	129.05	14.15	31.60	
Mar	199.10	234.54	2.65	9.35	99.70	25.67	22.35	205.74	172.953 43.44	38.80	
Apri	139.95	—	6.68	16.90	82.90	53.42	83.80	260.42	18.33	45.78	
May	63	350.85	11.15	27.72	82.55	27.43	8.90	227.47	40.23	57.12	
June	145.20	—	24.45	31.20	80.45	33.56	7.70	189.40	122.57	51.11	
	973.74	998.54	78.08	94.77	546.45	207.46	104.78	1173.44	472.61	239.11	4893.48
July	149.50	375.00	4.15	38.70	72.90	35.90	17.57	217.81	56.78	62.46	
Aug	182.25	387.50	49.22	46.30	120.25	33.03	23.20	249.38	47.60	26.76	
	1236.79	1761.04	131.45	179.	745.60	276.39	145.49	1645.63	576.99	328.33	7096.48
	○	○	○	○	○	○	○	×	×	+	

CAREFUL RECORDS. A meticulous listing of expenses shows diligent care given to record keeping by both sisters. Usually Ophelia delivered the milk. Quite often, a morning's run could end disastrously. In a letter to a friend, she described avoiding a wreck but having milk cascade all over her. (Courtesy of the Georgia Department of Natural Resources, Hofwyl-Broadfield Plantation State Historic Site.)

A Clear View. A Hofwyl milk bottle is representative of the change in the sisters' lives when they were no longer Savannah belles but working farm girls. Ophelia had been teaching at Wykeham Rise in Connecticut when she returned home to help the family. A letter Ophelia wrote to her friends at school vividly captures what she faced: "What am I doing! Why the things I do a day would fill a book. Firstly Miriam has gone away till Xmas, and on my shoulders have fallen a million things that she used to do. I always knew she did a lot but I never dreamed how much until I had to take them up! The dairy I have learned to like tremendously, love fooling around milk and making butter & putting it up in one pound packages, but the chickens!!!!!! I loathe them. . . . a deadly disease has 'descended' upon then, and I have to spend all my days running them down and ramming medicine down their throats!" (Photograph by Kathy Stratton; quotation courtesy of Arabella Cleveland Young.)

CATTLE GRAZING. The upper land of the plantation provided pasture for the herd of cattle that now grazed at Hofwyl. Even the old rice dikes could be used, as the cattle grazed there. In the early part of the 20th century, as the timber boom ended, the mills closed, and the economy slowed along the coast of Georgia, small-acre farming sustained many families. Those who had worked before at Hofwyl, such as Jerry Rutledge, returned to work in different capacities within the dairy operation. Just up the road on Highway 17, the Dents acquired a new neighbor. Col. Tillinghast Huston, one of the owners of the New York Yankees, came south. He purchased Butler Island Plantation and established a dairy. The two families became close friends. Later they sold their milk to him as the sisters began to tire from the actual delivering of it. Hofwyl Dairy would close in the early 1940s, as more stringent rules were passed governing home dairies. (Courtesy of Georgia Archives, Vanishing Georgia Collection, gly167.)

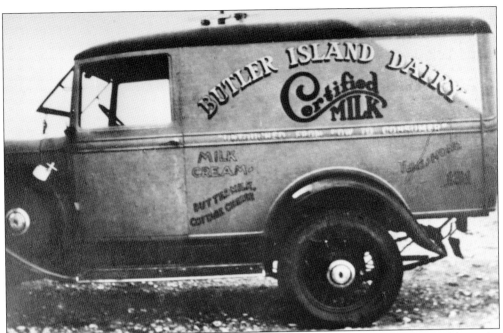

DELIVERY UPSCALED. Whereas the Dents had relied on their own automobiles to deliver the milk, Huston, with his entrepreneurial spirit, took to the road around 1932 with "Butler Island Dairy" proudly emblazoned on a delivery truck. Visitors were encouraged to stop at the dairy barn, see the cows milked, and buy ice cream churned on the spot. (Courtesy of Georgia Archives, Vanishing Georgia Collection, gly065.)

A FRESH CROP. Huston took great pride in raising champion cattle. Janice Andrews of Darien had the honor of having a cow named for her. Her father worked for Huston, and the family lived on Butler Island. From the operation of the dairy, Huston ventured into truck gardening. Soon trucks were leaving Butler Island loaded with iceberg lettuce. (Courtesy of Mrs. Charles Andrews.)

THE KILGORE SEED COMPANY

KILGORE'S
BRED-RITE
S E E D S

PLANT CITY, FLORIDA

H. R. MANEE
PRESIDENT & TREASURER

H. W. SCHNECK
SECRETARY & SALES MGR.

FLORIDA STORES
PLANT CITY PALMETTO
BELLE GLADE POMPANO
PAHOKEE SANFORD
MIAMI VERO BEACH
GAINESVILLE WAUCHULA
HOMESTEAD WEST PALM BEACH

May 7, 1945

THE KILGORE SEED COMPANY GIVES NO WARRANTY,
EXPRESS OR IMPLIED, AS TO THE PRODUCTIVENESS
OF ANY SEEDS, BULBS OR PLANTS IT SELLS AND WILL
NOT BE IN ANY WAY RESPONSIBLE FOR THE CROP.
ITS LIABILITY IN ALL INSTANCES IS LIMITED TO THE
PURCHASE PRICE OF THE SEEDS, BULBS OR PLANTS.

Miss U. S. Duet,
Hogwye Plantation
Brunswick, Ga.

Dear Miss Duet:

 Thank you for your order of the 5th which went out by
mail on that date. It was necessary to send you U.S.No.4 beans
instead of the No.3 as the U.S.No.3 have not been available this
season due to seed crop failure. We hope the substitution will
be satisfactory.

 The order totaled 70¢, leaving 30¢ due you for which we
are enclosing our check.

HORTICULTURAL PURSUITS. Both sisters gardened and continually sent flowers from Hofwyl north to friends. Their letters speak of preserves put up and vegetables canned. At the time when everyone had a Victory Garden, the Dents too were ordering seeds. The strange name of Hofwyl was hard to discern, given each sister's penchant for open, rounded letters. (Courtesy of the Georgia Department of Natural Resources, Hofwyl-Broadfield Plantation State Historic Site.)

JUST A TRACE. Of any job on a rice plantation, one of the most important was the trunk minder. The wooden trunks were the gates that allowed the tide to enter and to ebb. The timing of the opening and closing of them was critical for the success of the crop. Probably hewn from the vast stands of cypress, the vestiges of a few of the old trunks can still be seen in the marsh muck at low tide. Part of the wooden assembly was anchored deep into the dike to support the weight of the gates as the strength of the water pushed against the locked gate. Captured in graphite by artist Jeannine Cook, this rendering of a rice plantation trunk underscores the engineering involved in rice cultivation and captures a reminder of the era. (Courtesy of Jeannine Cook.)

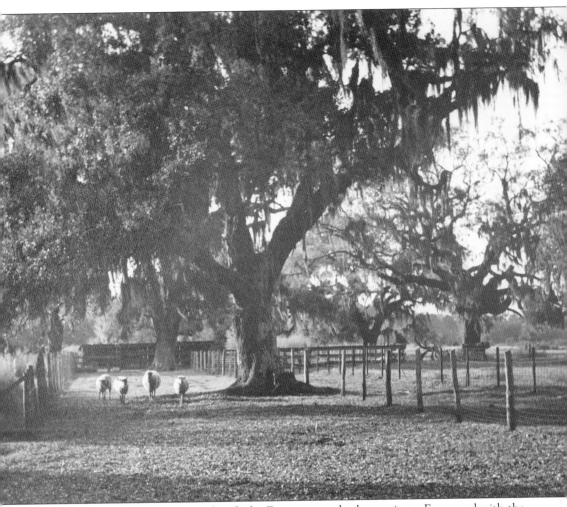

INTO THE FOLD. After the dairy closed, the Dents pursued other projects. Enamored with the beauty of their surroundings, they commissioned famed South Carolinian Carl Julien to pay a visit to Hofwyl. Sheep coming to the barn, ducks gathered at a water sprout, and ancient live oaks were just a few of the glimpses he caught with his camera. (Courtesy of Georgia Archives, Vanishing Georgia Collection, gly170.)

Hofwyl Broadfield Plantation

TOLLING OF THE BELL. Once the farm bell summoned those working on the farm to come for lunch or to share in news. The passage of time silenced the ringing of the bell. During World War II, many that had worked at Hofwyl found much better jobs in the shipyard in Brunswick, where 99 Liberty ships were built and launched. Few workers were available for the plantation during the war years. With frugality, the sisters lived on savings invested by their good friend Pierre du Pont. When her sister Miriam died in 1953, Ophelia was too married to the land to leave it. Instilled in her was such a strong sense of place. It was the same feeling for the land itself that her father, James Troup Dent, had possessed. Occupied with correspondence to friends and family near and far, Ophelia Dent stayed on at Hofwyl. In selecting an image for the first official pamphlet to be given to visitors to Hofwyl, the Georgia Department of Resources chose the old farm bell. (Courtesy of Albert Fendig Jr.)

Four

THAT "OLD BARN OF A HOUSE"

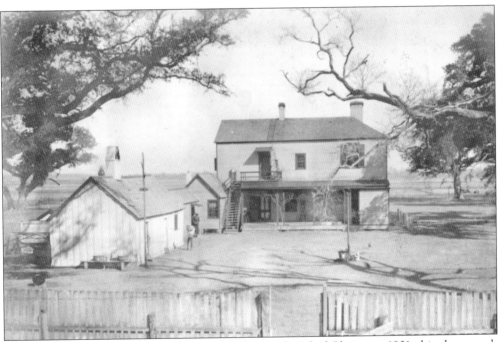

BLEAK AND BARE. Saved in a scrapbook at Hofwyl and marked Christmas 1901, this photograph disproves the myth that Georgia plantations were all white columns and verandas. Ophelia Dent herself referred to it as "that old barn." However, foremost in her mind and that of her mother's and sister's was that the house be maintained. Annual rituals took place. The wide-plank floors of heart pine were scrubbed with lye each spring. Today part of the Hofwyl experience is to walk inside the home and see the layering of generations, the blending of tastes and styles, and the eclectic manner in which a priceless antique is set next to a good reproduction. Ophelia Dent was quick to say that she lived with hand-me-downs, but as Anne Shelander Floyd in a talk about the furniture noted in 1986, "What wonderful hand-me-downs they were." (Courtesy of Georgia Department of Natural Resources, Hofwyl-Broadfield Plantation State Historic Site.)

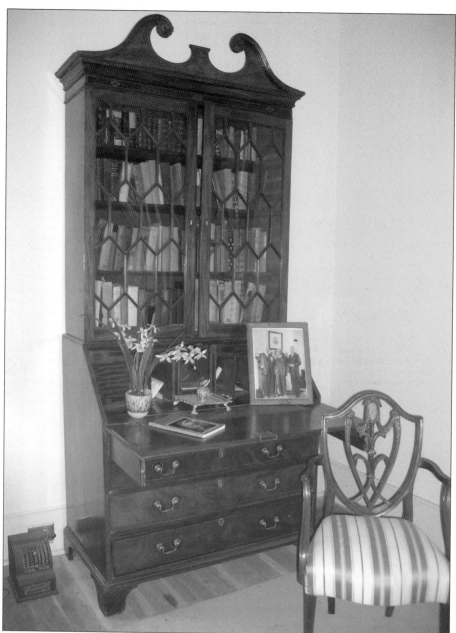

CHARLESTONIAN STYLE. The grandeur of this piece speaks for itself. Dated from the 1790s, the maker was probably a skilled craftsman in Charleston, where the family had roots. The patina that time gives to the wood makes its finish outstanding. A series of hidden drawers are part of its design. The piece was definitely used by the family; books occupy each shelf, and a photograph of a gathering of Du Ponts sits on a corner of the desk. Both the secretary and the accompanying chair, possibly a Philadelphia piece, were featured in an article in the magazine *Antiques* on two separate occasions. The sisters took pride in their antiques, queried experts about them, and studied about the famous cabinetmakers. What belonged to whom at Hofwyl and to what period it might belong has been studied by several authorities on antiques, such as the late Henry Green, considered the authority on Georgia Piedmont furniture. (Photograph by Kathy Stratton.)

TRAVELS FAR AND WIDE, NOW AT REST. This exceptional sideboard by Joseph Barry of Philadelphia, with matched knife boxes along with a representation of the family's silver, has a provenance worth relating. Rebecca Gratz bought it for her home in Philadelphia in 1769. The Dent family later acquired it from Gratz, who was their mother's great aunt. Used in the Savannah home, the sideboard came to Hofwyl in the 1930s only to return to Savannah following Dent's death. Cousins there offered the piece at auction in New York. An agent for Andy Warhol purchased it from Sotheby's. The Gratz sideboard graced the dining room of Warhol's home. In *Possession Obsession Andy Warhol and Collecting*, published by the Andy Warhol Museum, several photographs feature the sideboard. After Warhol's death, once again the piece traveled to the auction block. Some stories have good endings. This outstanding work of American craftsmanship is now part of the collection at Winterthur Museum and Country Estate in Winterthur, Delaware. Winterthur was the home of another Du Pont acquaintance of Ophelia Dent: Henry Francis du Pont, who was well known as a horticulturist and collector of early American furniture and decorative arts, especially of the Federal period. Dent noted in a letter to a friend that du Pont was turning his home into a museum. The inclusion of the Gratz sideboard in the collection would have pleased her. (Courtesy of Georgia Archives, Vanishing Georgia Collection, gly191.)

CENTER OF THE HOME. Book-topped tables, packed bookshelves in their grandfather's towering bookcase, and an assortment of period chairs indicate how used the living room was. In the summer, rugs were rolled up and stored. White slipcovers covered the upholstered pieces, part of what Rudolph Capers called "summer-dress." With no air conditioning, doors under the windowsills were opened to catch marsh breezes. (Courtesy of Georgia Archives, Vanishing Georgia Collection, gly199.)

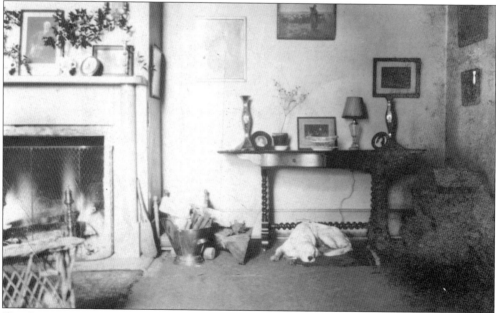

THE HEARTH. The fireplace blazed at Hofwyl during the cold winter months. Over it hung a series of photographs, one thought to be of Camilla Brailsford. Another captures the likeness of George Columbus Dent, son of John Horry Dent, who once served as second in command of the USS *Constitution*. The Dents relished the pictures of their ancestors and knew the accompanying stories of each likeness. (Courtesy of Arabella Cleveland Young.)

JAPANNED TREASURE. Part of the layering of Hofwyl is the collage of often-unrelated objects. This particular box is representative of the art of Japanning. In this process, layers upon layers of lacquer were built up and painted. The process developed in China, and often furniture and objects were made in America and shipped to China to be decorated. (Photograph by Kathy Stratton.)

HOFWYL LEGEND. Along the Altamaha Delta, plantation names mirrored those of a family or connected with the locale. All who visit Hofwyl wonder at its strange name. Over a table in the living room hangs a print of the school that George Dent attended in Switzerland and for which he named Hofwyl. Then modeled under the concept of a working school, the school is still active near Bern. (Photograph by Kathy Stratton.)

FROM THE GOVERNOR. Governor Troup's daughters, Florida and Oralie, were close to the George Columbus Dent family. At some point, this gracious card table and the four chairs became fixtures of Hofwyl's entry hall. The mahogany sheen of the furniture contrasts with the heart pine floors and offers another example of the incongruity in furnishings, which is part of Hofwyl's charm. (Photograph by Kathy Stratton.)

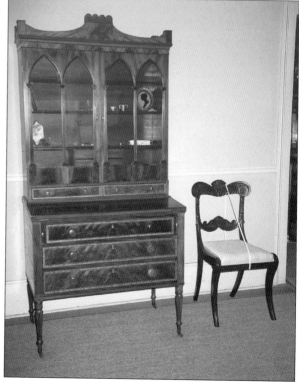

ANTIQUING FORAYS. Good friend Arabella Cleveland, who first met Ophelia Dent at Wyckham Rise, remained a lifelong friend and frequently visited Hofwyl. This small secretary in the hall represents their shared passion for collecting. Cleveland recommended that the sisters purchase it. Its reeded legs display fine craftsmanship. The piece also represents a very good investment for the Dents. (Photograph by Kathy Stratton.)

ADAPTED USE. Solomon Cohen's handmade bookcases, coming via Georgetown to Savannah, found a new use when Hofwyl became home. Ample, thick shelves held the family's Canton china. Part of the Oriental trade, the china was often ballast, sold when a ship was unloaded. The Dents fervently collected it. In her will, Ophelia Dent left specified pieces to her close friend Jenny Emanuel and others. (Photograph by Kathy Stratton.)

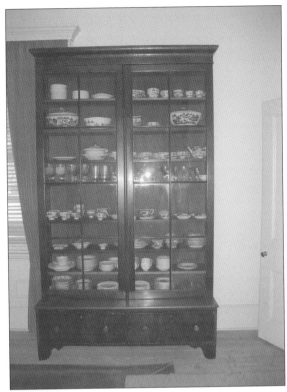

TREASURES FROM THE ORIENT. The dining room at Hofwyl features some of the family's unique pieces of Canton china. The fish-shaped bone dishes hearken to a time when cutlery included fish knives and required appropriate receptacles for bones. China by Limoges, Meissen, and Wedgwood fill out the family's collection. A family friend recalls her mother and Ophelia visiting Savannah antique shops searching for Canton china. (Photograph by Kathy Stratton.)

AN EXTRAVAGANT EVENING. Part of the joy of touring the rooms at Hofwyl is to glance at something totally outside one's sphere. Placed on a sofa, this fine example of an ostrich-fringed fan speaks of generations that dressed and attended grand balls. The framework of the fan is of tortoise, evidently carefully handled through the years so that is remains in pristine shape. (Photograph of Kathy Stratton.)

PATIENT PENELOPE. Able to whip out a pistol at a moment's notice, Ophelia Dent possessed talents on her distaff side. With steeled patience, she knitted this counterpane for her bed. On a side table lies one of the last squares she was completing before her death. (Photograph by Kathy Stratton.)

TWO-POSTER SPLENDOR. In the upstairs bedroom stands an example of the fine furniture that was made and adapted by craftsmen on this side of the Atlantic. Hofwyl's rice bed, reputed to be one of only a few known, displays an interesting practicality of design. The two forward posts portray sheaves of rice, while the two back posts are from cypress wood and unadorned. (Photograph of Kathy Stratton.)

FINENESS OF DESIGN. Another feature of this rice bed is that the headboard may be removed to allow air circulation in the summer. Curtained with heavy fabrics in the winter, the back post did not merit the woodcarver's talent, which captured the acanthus leaf and drapery on all sides of the two front posts. Only Charleston beds were known to employ the rice motif. (Photograph of Kathy Stratton.)

A MOMENT IN TIME. Hanging in the small bedroom upstairs, a calendar dated 1903 turns back the clock. Items such as this add to the Hofwyl story. A lap desk made when George Dent was at Hofwyl serves as a reminder of his student days. According to records, this small room saw service at one time as both a nursery and an office. (Photograph by Kathy Stratton.)

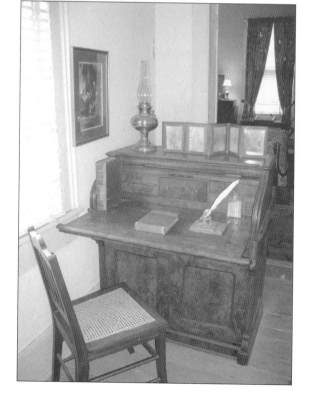

DAILY RECORDS. This handsome desk with touches of burl veneer may have been used to keep the records for the plantation or the dairy. Additional uses of the room were for sewing and dressing. The landing just outside the room holds a chest and linen press. Another small bedroom, noted by guides as the "Quarantine Room," was used for isolation. (Photograph by Kathy Stratton.)

A SMALL GUEST. A small rocker sits as a reminder of the various children who grew up in the house at Hofwyl. When the state began cataloguing Hofwyl's contents, a trundle bed stored in the attic was placed on display. It too serves as another reminder of the young Dent children, who found an early freedom in visits to Hofwyl. (Photograph by Kathy Stratton.)

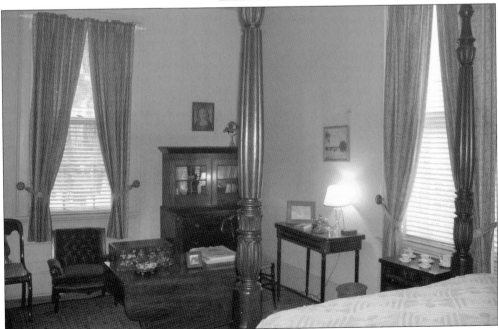

HELD IN REPOSE. Pondering the different personalities of the two sisters is of interest to the various guides. The books in this room reflect Miriam's interests, like those of her sister, in music, art, and history. Again the spread on this bed was made by a family member and is credited to the talent of grandmother Ophelia Troup Dent. (Photograph by Kathy Stratton.)

FOR GRATZ OR GUESTS. When he was able to come down from Savannah, Gratz involved himself in the running of the dairy and other projects that interested him. This larger of the two back bedrooms upstairs contains memorabilia connected with him. The additional sleeping couches upstairs saw use when the house was full of guests. Early letters mention friends who would come for extended stays. Several large wardrobes, placed around the landing functioned as closets. During the summer, quilts could be stored in them. Ophelia Dent stated in her will that her linens, counterpanes, and coverlets were to go to any of those mentioned in the will that might want them. From this floor, there is access to an attic where much accumulated through the years. At one time, there were backstairs, leading down from a door on the second floor. (Photograph by Kathy Stratton.)

NOW COLLECTIBLE. The porcelain chamberpot (below) with its decorative flower decal sits nestled under an upstairs bed and serves as a reminder that indoor plumbing did not come to many houses until the 1920s. A later bathroom was added on the first floor. Books form another classification of collectibles. Not to be overlooked is the Dents' library. Ophelia willed a set from Sapelo, which may have belonged to Thomas Spalding, to a close friend. Autographed books sit on tabletops. Margaret Mitchell was a favorite visitor, along with Medora Fields Perkins. Dent evidently recorded who borrowed a book, and expected them to be returned. (Photograph by Kathy Stratton.)

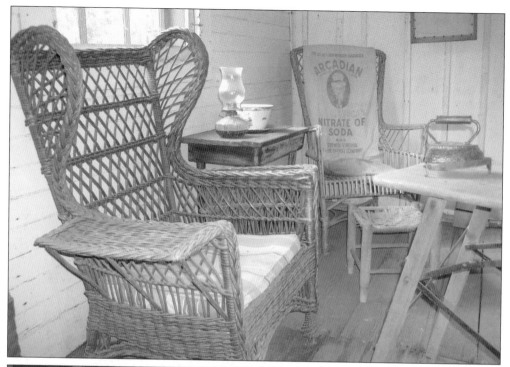

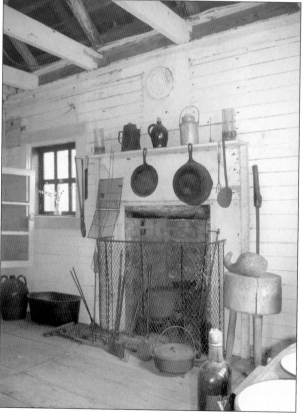

JUST TO SIT AWHILE. During plantation days, most kitchens were set away from the house. The reason for this placement was fear of fire. A removed distance also kept the heat out of the house. Rudolph Capers, the butler for Hofwyl, stayed in these quarters. His family lived at nearby Ridgeville, but as Ophelia Dent aged, he would stay during the week. The summer kitchen displays various cooking utensils, bowls, and cast iron skillets that could have been used through the years by different cooks. Friends remember with relish the thin sugar cookies that Rudolph made and had ready for impromptu visits. (Photograph by Kathy Stratton.)

Five

DEVOTED HOFWYL FRIENDS

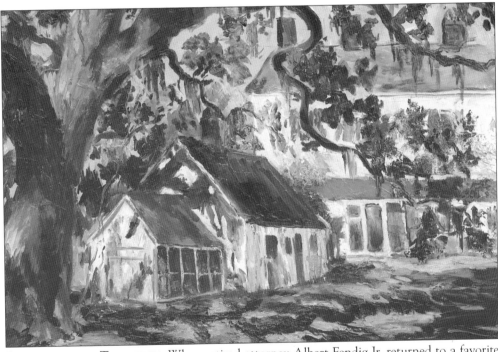

CARRYING ON A TRADITION. When retired attorney Albert Fendig Jr. returned to a favorite pastime, finding a subject to paint posed no problem. Since childhood, Fendig had known the Dents and had visited with them. He recalled as a child hearing the milk from Hofwyl Dairy being deposited at the family's door. He also remembered seeing Ophelia Dent pick up a shotgun and dispose of a rattlesnake. As his father had done, Fendig Jr. took an active interest in Hofwyl. He helped charter Friends of Hofwyl, the first Friends' group for a state park in Georgia. Nothing pleases Fendig more than to take a friend and set up on the lawn at Hofwyl for an afternoon of *plein aire* painting. Under the shade of one of the great oaks with shadows falling on the buildings, his painting captures the welcome that Hofwyl has always offered to those who chose to stop and visit. (Courtesy of Albert Fendig Jr.)

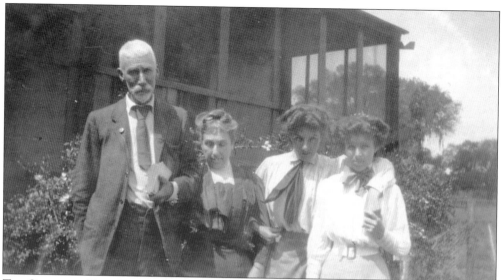

THE GIRLS AND THEIR PARENTS. Pictures in the scrapbooks at Hofwyl show the sisters at different stages of their lives. There are few images of brother Gratz, and fewer of their parents. However, the family's warmth made Hofwyl a place for people to gather. In the early 1900s, just arriving at Hofwyl called for an adventurous spirit. (Courtesy of the Georgia Department of Natural Resources, Hofwyl-Broadfield Plantation State Historic Site.)

CROSSING THE WATER. Until the 1920s, traveling the coast of Georgia involved boat traffic. Dressed in their best, even with hats on, this family appears to be returning to Darien, possibly after an outing to Hofwyl. Located north of Brunswick in McIntosh County, Darien was the home to various members of the Dent and Troup families throughout the 18th, 19th, and 20th centuries. (Courtesy of the Georgia Department of Natural Resources, Hofwyl-Broadfield Plantation State Historic Site.)

COTERIE OF FRIENDS. School fiends were important to both sisters. They attended Miss Hartridge's school in Savannah. Ophelia Dent is on the far left. Several of their friends from there would remain lifelong ones. The more adventuresome ones were sure to appreciate a weekend at Hofwyl as a definite change in pace from their sedate lives in Savannah. (Courtesy of Georgia Archives, Vanishing Georgia Collection, ctm228.)

BUCOLIC EXPERIENCE. Visiting Hofwyl in the early 1900s meant taking a step back in time. Butter was still churned the old-fashioned way. The novelty of the experience brought visitors back frequently. Meeting and talking with those who worked at Hofwyl was very much a part of any visit there, and visitors loved to hear stories of the old days. (Courtesy of Georgia Archives, Vanishing Georgia Collection, gly196.)

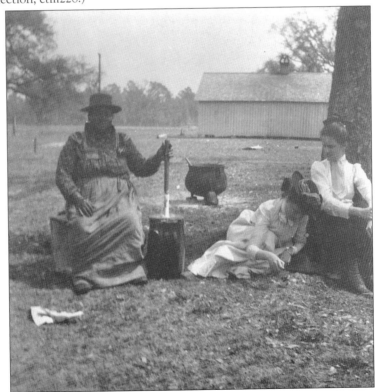

DOCKING AT HOFWYL. Sisters Miriam and Ophelia often noted the date of an outing, but seldom those in attendance. Many of the same faces appear in the albums indicating that once a person visited Hofwyl he or she was likely to return. In later years, Clermont Huger Lee of Savannah would label some of the albums. (Courtesy of the Georgia Department of Natural Resources, Hofwyl-Broadfield Plantation State Historic Site.)

CANINE FRIENDS. Pictured from left to right, Ophelia, Miriam, and an unidentified friend play with one of the family's pets. No visit to Hofwyl was complete without getting to know the members of the family. Dogs, sheep, cattle, even a parakeet once were just a few of the animals found at Hofwyl. Usually there were multiple dogs, with a variety of names. (Courtesy of the Georgia Department of Natural Resources, Hofwyl-Broadfield Plantation State Historic Site.)

HOFWYL HOUSE PARTY. From letters and recorded interviews, the personalities of the Dent girls reflect a devotion to friends. Their spirits were adventuresome, and they were well liked by their peers. They shared their home, kept up with correspondence, and forged strong ties with family. The Phillips cousins, Fanny, Georgina, and Henrietta, three maiden ladies buried in the Cohen plot at Laurel Grove Cemetery, were among their favorite friends. From an album at Hofwyl, this photograph from the early 1900s shows one such group posing as a reminder of Hofwyl fellowship and fun. Pictured from left to right are (first row) Miriam Dent, Clermont Huger, Ralph Bristol, Dr. Albert Lamb, and ? Harris; (second row) Betty Lamb, Dan Hull, Fanny Phillips, and Elfrieda DeRenne. Hull was a frequent visitor along with George Smith of Savannah. DeRenne from Wormsloe would marry Craig Barrow and remain a close friend, as did Huger-Lee. (Courtesy of the Georgia Department of Natural Resources, Hofwyl-Broadfield Plantation State Historic Site.)

CLOSENESS OF ASHANTILLY. The Dent family's roots connected with Thomas Spalding, a notable Georgian who owned Sapelo Island yet retained a home on the mainland at Darien, named for the ancestral Scottish home. Their great-grandfather Dr. Troup attended Spalding's family and slaves. In the 1900s, the William Haynes's family purchased Ashantilly. They and their children became some of the Dents' closest friends. (Courtesy of Georgia Archives, Vanishing Georgia Collection, mci004.)

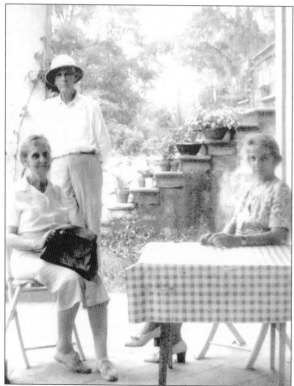

TRAVELS ABROAD. Correspondence suggests that the elder Haynes and the sisters enjoyed traveling together as well as attending cultural events in Savannah. While the son and two daughters attended school in New York, the Dent sisters may have filled a void for the parents. Ophelia is seated on the right with Laura Lee Haynes. Each family had the responsibility of maintaining an older home and large acreage. (Courtesy of the Ashantilly Center.)

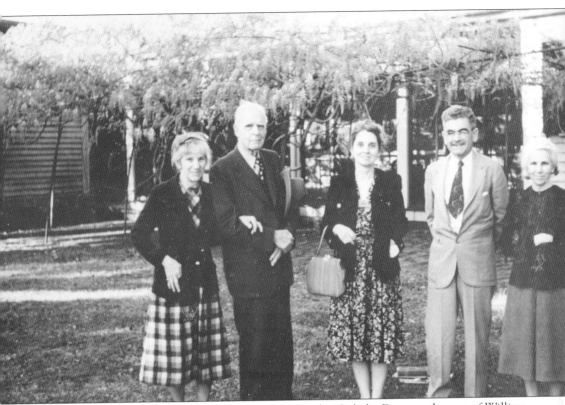

DEEP TIES. In a photograph dated 1953, from left to right, Ophelia Dent on the arm of William Haynes; his daughter-in-law, Natalie Haynes; close family friend Dr. Albert Galin; and sister Miriam posed in the spring in front of the Chinese wisteria replete with blooms. This was probably one of the last pictures taken of Miriam, who died in June 1953. Dr. Galin, who practiced medicine in Brunswick for many years, shared many of the same interests of the sisters. Their quick wit sparred with his. He was a regular guest at Hofwyl for lunch or dinner. One of their favorite pastimes was collecting Canton china. An earlier will of Ophelia's gave Dr. Galin first choice on any pieces he might want. Later his collection would be gifted to the Telfair Museum of Art in Savannah. Members of the Haynes's family, Anne Lee, Frances F., and William G. Haynes Jr., were gifted in each version of her wills as were the Savannah Phillips cousins, along with other family members and friends. (Courtesy of Georgia Archives, Vanishing Georgia Collection, gly203.)

JUST DOWN THE ROAD. Hofwyl lay at the juncture of the two coastal counties of McIntosh and Glynn and north of the city of Brunswick. Years later, Ophelia Dent would admonish highway engineer H. J. Friedman and demand that a new routing of Highway 17 swing wide around the family property. Just past the delta, Glynn County ended, and McIntosh began. Therefore, their milk route took them north and south and even to Jekyll Island. In Brunswick, the county seat

of Glynn, they could shop or visit with friends. Temple Beth Tefilloh and St. Mark's Episcopal Church were in the city. Brunswick was also the gateway to both St. Simons Island and Sea Island once the Fernando J. Torras causeway was completed in 1924. The above painting captures downtown Brunswick about 1902. (Courtesy of the *Brunswick News*.)

Fourth of July
AT
St. Simon Island.
Boat Races,
Bicycle Races,
Other Attractions.

Under the auspices of the Cumberland Route and the Hessie Line. Boats will make extra trip.

See both schedules elsewhere.

Everybody go and Have a Good Time.

A WORTHY CAUSE. Letters to a friend during World War I capture Ophelia's reaction to the war. "I'm about to commence first aid & surgical dressing, and that ought to be very useful on the Plantation even without war." Other letters would lament the fighting. Millard Reese, cited in the Red Cross article, was one of Dent's golfing partners. (Courtesy of "Porthole to the Past," the *Brunswick News*.)

CELEBRATION ON THE ISLAND. During the late 1800s, the Georgia coast became a vacation destination. The railroads brought people there while boats plied up and down the waterways. Born in 1886, Ophelia Dent's natal year corresponded to the building of the Jekyll Island Hotel, an exclusive enclave for some of the nation's wealthiest families. (Courtesy of *Brunswick Times-Call*, July 4, 1901, Three Rivers Regional Library.)

1918

ANNUAL MEETING OF THE RED CROSS

WILL BE HELD IN CITY HALL ON THURSDAY NIGHT, April 11.

The local chapter of the American Red Cross, of which Millard Reese is president, will hold their first annual meeting in the City Hall on Thursday April 11, at 8 o'clock, at which time it is expected that quite a large number of Red Cross workers will be present.

Several prominent speakers have been invited to be present and make addresses, however, those in charge of the affair are not ready to make the announcement of the speakers. Besides speaking a general review of the splendid work performed by the Red Cross in Brunswick and the State will be gone over. A large display of bandages, socks, sweaters and other useful things for soldiers that have been made by the local chapter, will be expedition and may be viewed by the public, which has a cordial invitation to attend the meeting and learn more of the usefulness of the American Red Cross. Then local chapter has sent many useful articles to the battlefields of Europe, such as hundreds of bandages, etc., and is now working every day at their rooms in the Armory building on Richmond street. If you are not thoroughly familiar with the workings of the American Red Cross you would do well to attend the meeting in the city hall on Thursday night, April 11.

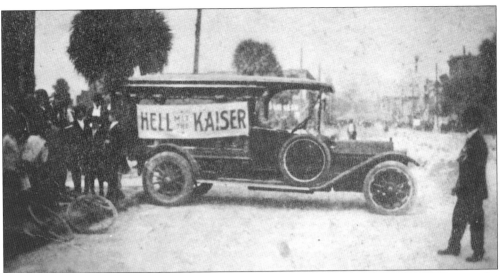

SPIRITED CONFLICT. World War I–era children delighted in the lyrics "Kaiser Bill Went up the Hill," while adults harbored a stronger animosity against Germany, as demonstrated in this image. Ophelia continued with surgical dressings: "Tuesday we make them and Saturday Irene and I pack them up, Stamping etc. etc. I passed the first aid exam swimmingly and am waiting for the next course which is higher and harder." (Courtesy of Georgia Archives, Vanishing Georgia Collection, gly012.)

PASSION FOR THE GAME. From her days at Rosemary Hall and Wykeham Rise, Ophelia Dent loved sports. Competitive and talented, she loved golf. Brunswick's first course, pictured 1918, was the site where she played. "We had a very fine 2 ball mixed foursome on Saturday, the first of a series, with tea Saturday afternoons which is a great innovation for Brunswick." (Courtesy of Georgia Archives, Vanishing Georgia Collection, gly046.)

R.M.S. "Berengaria"
Cunard Line

THE WIDE WORLD. For Ophelia Dent and Miriam, their life revolved around the dictates of the dairy. Yet, each found time to leave and travel. Ophelia's dear friend Alice Belin had married William du Pont. As neighbors at nearby Altama Plantation, the Du Ponts "the ones who bought the plantation next to us last year" included Ophelia in activities not only locally but also abroad and at their home Longwood, in Pennsylvania. Today Longwood Gardens, near Kennett Square, remains open to the public as an outstanding horticultural showplace. (Courtesy of Arabella Cleveland Young.)

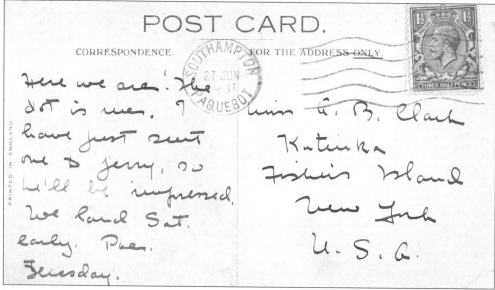

LIFETIME OF CORRESPONDENCE. The friendship of Arabella Cleveland and Ophelia Dent spanned over 50 years. Each visited and introduced the other to a wide circle of friends. Through Cleveland, Dent would meet and exchange Christmas cards with Andrew Wyeth and his wife, who lived adjacent to the Clevelands in Chadds Ford, Pennsylvania. She would also hold dear her friendship with the Cleveland children through the years. Fortunately, daughter Arabella Cleveland Young patiently typed the correspondence between her mother and the Dent sisters. (Courtesy of Arabella Cleveland Young.)

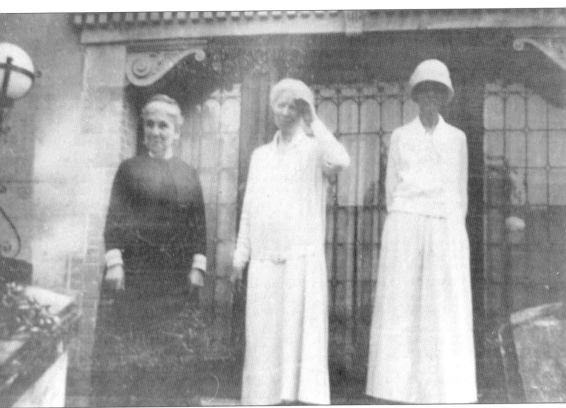

CLOSE TIES. By delivering milk to club members when they were on Jekyll Island, Ophelia Dent became a good friend to the Maurice family. She numbered Cornelia, Emily, Marian, and Margaret among her friends. Pictured in front of the Maurices' Jekyll Island home, Hollybourne Cottage, from left to right are Miriam Dent, Marian Maurice, and Margaret Maurice. Their friendships lasted through the years. Photographs at Hofwyl document house parties they attended together. Jekyll Island Club historians June and Bart McCash supplied the names of members of the Maurice family to photographs at Hofwyl in 1985. Going to Jekyll was a special event. "I am going to Jekyl Island on Monday for a week where I'll get lots of tennis and swimming too, and riding I hope. I've worn out a perfectly good pair of tennis shoes already and I've improved a lot, but after this month & next I don't expect to play more. . . . I had a gorgeous time at Jekyl and what I lost in golf I gained in tennis because I've never had such good tennis as in the tournament." (Courtesy of the Jekyll Island Museum Archives.)

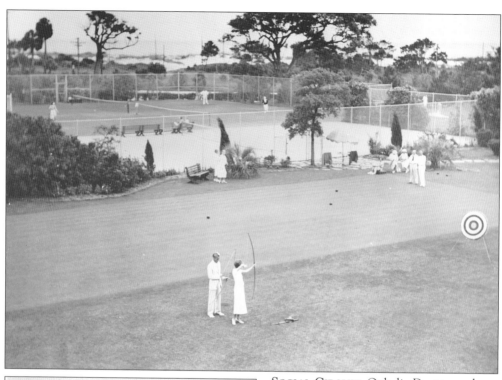

SEA ISLAND
'SHORE LINES'

THE CLOISTER
SEA ISLAND, GEORGIA

VOLUME 6 CHRISTMAS, 1938 NUMBER 1

Merry Christmas

YOUR CHRISTMAS AT SEA ISLAND, MEANS—

Not only a festive and friendly atmosphere, bracing climate, the most complete round of southern sports spread before you for choice, a round of holiday features appealing to all ages and tastes, the refreshing beauty of clear crisp days against a background of green foliage and bright semi-tropical flowers—

But, an entire staff planning for your pleasure, anxious to make this your happiest holiday season!

After completing a successful summer season at his delightful Oysters Harbor Club, on Cape Cod, C. W. Wannop has returned, accompanied by gracious Mrs. Wannop, and is beginning his fifth winter season as manager of The Cloister.

The warmest of welcomes is being extended—

(Continued on page 2)

THE CLOISTER CENTERS HOLIDAY FESTIVITIES

Christmas Eve marks the beginning of a program of varied and gay holiday events planned for Cloister guests and members of the Sea Island residence colony. The special Christmas Eve dinner-dance on Saturday evening, December 24, will be followed by a Christmas Tree party for all ages to be held in the Spanish Lounge at 9:30 o'clock. Carol singers will bring a program of Yuletide music, after which there will be a gala holiday dance in the Cloister Club Rooms, featuring a (Continued on page 6)

NEW ORCHESTRA

With each member an accomplished musician, Harry Van Ham's orchestra has had numerous successful engagements at hotels, especially resort hotels, and during the past (Continued on page 2)

Your CHRISTMAS Presence at SEA ISLAND

SOCIAL CIRCUIT. Ophelia Dent toured her stream of visitors around. When Sea Island Company opened The Cloister hotel in 1928, Dent met many of the first cottage owners. The golf course beckoned as well as the hotel. "Bless Pat! We lunch tomorrow with Mrs. Brookes at Cloister!!! You had better come back, you are missing the one social week of the year." (Courtesy of Georgia Archives, Vanishing Georgia Collection, gly058.)

SEASON'S EVENTS. Christmas cards went out to a growing network. Edged with a red border, usually on Tiffany stationery, the cards featured some aspect of Hofwyl. A 1936 Christmas note had local interest: "Lots of new and lovely houses seem to have sprung up, and the Cloister has built in over the garden between the hotel and your shop. They have done it awfully well." (Courtesy of Sarah Cornelia Leavy.)

A very happy Christmas
and love from

 Ophelia and Maximilian.

This is taken from an upstairs
back hall window looking past
the Wisteria down below, to and
the barns.

FRIENDS FAR AWAY. The Dents had lived at Hofwyl so long and had such deep family roots that visitors often came to talk with them about the history of the area and those who had lived along the Altamaha Delta. One such person was Lyn Newman from England, who rented a house on the island and became a friend of the Dents. Newman had known most of the Bloomsbury group, including Virginia Woolf, and had worked for Leonard Woolf. An author herself, she began research on the life of Fanny Kemble. The Dents' correspondence continued through annual Christmas mailings. Newman saved the cards. This message noted, "This is taken from an upstairs back hall window looking past the wisteria down below, toward the barns." Newman's papers, along with those of her husband Max, a distinguished mathematician, now are in the Library, St John's College, along with her unpublished work on Kemble. (By permission of the Master and Fellows of St John's College, Cambridge.)

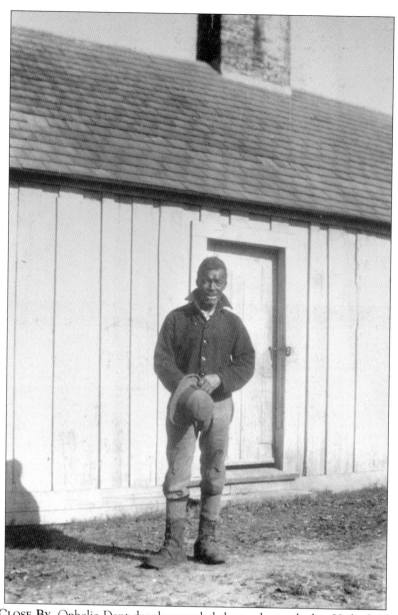

FRIENDS CLOSE BY. Ophelia Dent deeply regarded those who worked at Hofwyl. Her will left a stipend to the Abrams Home for Old Women in Savannah in memory of her old nurse, Ellen Connor. For neighbors and friends who lived in the Needwood area, she left carefully recorded amounts. She directed her executors to pay out the special bequests as quickly as possible as many of those receiving them were advanced in age. Jerry Rutledge, who had worked in the dairy barn, was remembered along with others. Rudolph Capers, likewise, received a bequest. His job continued as he became the first official guide of Hofwyl and worked there for an additional 10 years with the state. Jackie Edwards, who worked at Hofwyl as an interpretive ranger, knew Capers well and employed many of his stories in those that she so willingly shared with visitors. It was she who worked to restore the cemetery on Petersville Road, where descendants of the slaves who worked for the Dents in the 1850s were buried. (Courtesy of Georgia Archives, Vanishing Georgia Collection, gly182.)

Six

LORE AND ATTRACTION OF A SPECIAL PLACE

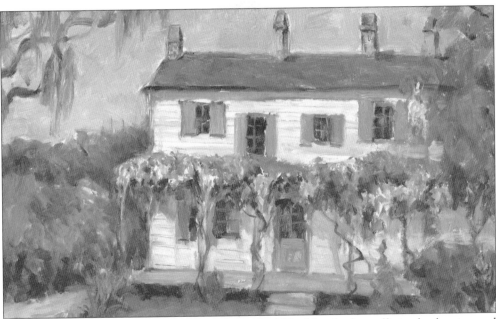

THE BACK PIAZZA. Renowned coastal artist Mildred Nix Huie had an affinity for drawing and painting the plantations that once existed both on St. Simons Island and on the mainland. She and her daughter published a series of books about them. *Hofwyl-Broadfield Plantation* related not only the history of Hofwyl but also of nearby Elizafield. Huie's oil that captures the annual blooming of the old Chinese wisteria hints at the feeling of nostalgia, which is a part of Hofwyl. On the back piazza, friends came to sit and talk, enjoying each other's company without hurry. It was here that Ophelia Dent was happy to welcome Matt Schaffer, son of her veterinarian, Dr. David Schaffer. Matt would record his memories of his conversations with Dent in an unpublished manuscript entitled *Ophelia and Me*. A graduate of Yale like Dent's brother and recipient of a Rhodes scholarship, Schaffer visited Hofwyl whenever he returned to Brunswick, planning one day to publish his story of a special lady and a special place. (Courtesy of Mildred Huie Wilcox, Left Bank Art Gallery, St. Simons Island.)

LONG BEFORE INTERSTATE 95. Getting to any destination along the coast took forbearance and luck. If the tide were out, the marsh could sustain some weight. To cross it, a person had to employ ingenuity. Laying boards as they went, some stalwart souls patiently laid their own road. The car pictured may date the photograph to about 1918. (Courtesy of Georgia Archives, Vanishing Georgia Collection, gly210.)

FERRYING ACROSS. Ferries proved a practical way to get goods across the water before bridges were built. As so many of the islands were either home sites or plantations, ferrying at that time represented a good income. Sadly, every now and then a car tumbled into the river or marsh. (Courtesy of Georgia Archives, Vanishing Georgia Collection, gly211.)

BEST FRIENDS. Shown with one of their favorite dogs, the sisters each year used their Christmas cards to remind their friends of what visiting Hofwyl meant. Those who came never minded the arduous trip to get there. Sharing a pleasant visit, Ophelia wrote, "We sat out and talked for hours." (Courtesy of Arabella Cleveland Young.)

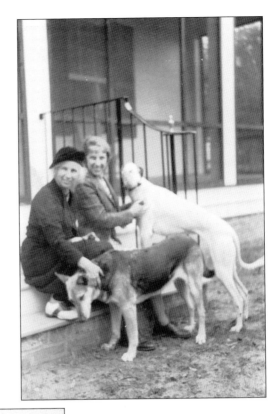

SIMPLE MESSAGE. Many of the examples of the Hofwyl cards sent through the years show little change in the context of the message. Other letters to friends though out the year might run much longer. But with a growing list of all the friends they visited, there was merit in brevity. (Courtesy of Arabella Cleveland Young.)

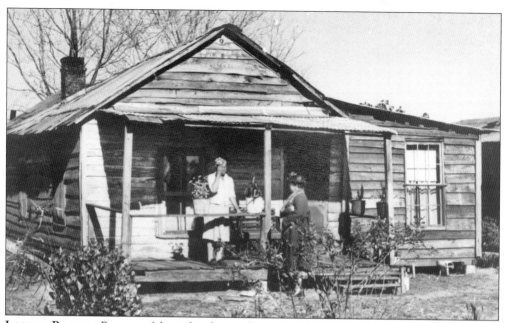

LORE TO RECORD. Because of the isolated coastal area, the Gullah-Geechee heritage was preserved and not diluted by commingling with outsiders. Margaret Davis Cate persevered in visiting families whose ancestors had been slaves. She recorded what they had to say and what they could tell her about folklore, medicine and superstitions. (Photograph by Dr. Orrin Sage Wightman, courtesy of National Park Service, Fort Frederica National Monument, Georgia Historical Society, the Margaret Davis Cate Collection, 997.)

December 22, 1938 SHORE LINES Page 3

MRS. CATE TO DISCUSS FORT FREDERICA, MILITARY ERA

Margaret Davis Cate, author of "Our Todays and Yesterdays" and other publications on the historical background of these Golden Isles, will talk informally at the tea hour on Friday, December 30, in the Cloister Spanish Lounge, her subject to be "Fort Frederica and the Military Era on Saint Simons Island." Mrs. Cate is not only an authority on the fascinating pages of early history enacted on these coastal islands, but her vivid and entertaining conversation makes the characters of by-gone days live again for her listeners.

Fort Frederica was the most expensive fortification erected by the British in North America, having been built with funds appropriated by Parliament and constructed by English soldiers and settlers under the direction of James Edward Oglethorpe, founder and first Governor of Georgia.

Built in 1736, this fortification was intended to protect the infant colony of Georgia and the other English possessions to the north against the Spanish in Florida. In 1742 Spain sent a fleet of 50 vessels and five thousand men to destroy the fortifications on Saint Simons Island. The victory of Oglethorpe's forces at Bloody Marsh turned the tide of Spanish invasion and secured English supremacy throughout this land.

To add to the interest of this historical sketch, Mrs. Cate plans to show her listeners pictures of the Fort, the barracks building, the mote, the burying ground, the church, and other interesting material.

For anyone wishing to visit the historical spots on the islands, Mrs. Cate has arranged a tour to the points she considers most interesting. Cloister guests may make arrangements to go on this conducted tour by contacting the desk or Mrs. Cate direct.

AT GOLDEN ISLES SHOP

Whether you need an extra outfit for beach or tennis, for golf or dancing, you can find just the right note in resort clothes especially selected for Sea Island wear at the Golden Isles Shop in the Administration Building, on the way to the Casino. Mrs. Margaret White Hancock, who has spent many seasons at Sea Island, was on hand at the first of the resort fashion showings to select the snappiest shorts and accessories, the loveliest tweeds and evening ensembles.

Cashmere and Brooks type sweaters are shown in the most delectable shades, with lengths of tweed to exactly match, and smart little suits and coats to match or contrast. There are play suits, flannels and other spectator sports models, bathing suits, and a variety of accessories from purses, tricky belts and scarfs to beach sandals, and all sorts of cunning caps. Mrs. Arthur Huston is associated with Mrs. Hancock.

HUNTERS BRING GOOD BAGS AT SEA ISLAND PRESERVE

Hunters during the early part of the season have been favored with unusually good luck this year at the Sea Island Hunting Preserve, where a large number have brought in the most coveted of game—native wild turkey—and many have bagged their limit of two of these wary game birds as well as their limit of deer and quail. The 65,000 acre Preserve is located two hours by motor or one hour by boat on the mainland south of Sea Island, and in the primitive forests and swamps of the Preserve there may be found an abundance of native wild turkey, deer, and quail. There is also a good chance for the hunter to bring in a wild cat, fox, or possum.

LET ME SHARE SOME STORIES. Margaret Davis Cate used her notes for lectures for the guests at The Cloister. They relished what she had to share, for they were visiting an area still quite natural. Cate made history come alive. In their 1955 book *Early Days of Coastal Georgia*, photographer Dr. Orrin Sage Wightman and Margaret Davis Cate preserved culture that could have so easily been lost. (Courtesy of Sarah Cornelia Leavy.)

SIBBY KELLY AT REST. Living in Petersville near Hofwyl, Sibby Kelly was accorded a "granny woman," or midwife. Margaret Davis Cate recorded that it was believed that "Old Sibby" brought more babies into the world than any white doctor who ever lived in Glynn County. Davis began her interviews in about 1936. (Photograph by Dr. Orrin Sage Wightman, courtesy of National Park Service, Fort Frederica National Monument, Georgia Historical Society, the Margaret Davis Cate Collection, 997.)

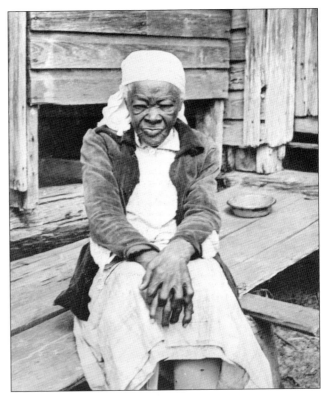

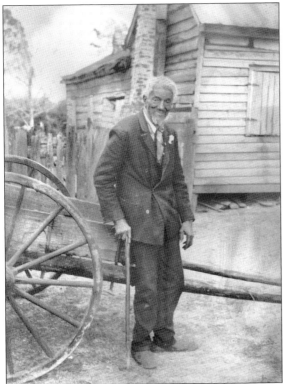

LOCAL LEGEND. In the Cate Collection, multiple boxes contain the photographs taken by Wightman. Liverpool Hazzard, a favorite subject, enjoyed telling his tales. The last of the Butler slaves, he claimed to be almost 110. In later years, Lady Alice Butler, granddaughter of Pierce Butler, gave him a monthly allowance when she came from England. (Photograph by Dr. Orrin Sage Wightman, courtesy of National Park Service, Fort Frederica National Monument, Georgia Historical Society, the Margaret Davis Cate Collection, 997.)

In the summer of 1890 Mrs.Kemble used the following language
to me at the end of a conversation in regard to the then impending
"Force Bill" in the U.S.

She was living with her daughter, The Hon. Mrs. J. W. Leigh, in
a small village in Surrey, near London. I was a guest in the house.

"I suppose the Southern people will never forgive me for what I
said about them in my book(" (Referring to her Journal on a Georgian
Plantation.)

I floundered the best reply I could think of. Something as to their
"better realizing the attitude of the world since that time" I knew she
was not forgiven.

Then Mrs.Kemble said what is the excuse for this insertion!

"I have bitterly regretted many things that I said in that book!
I was a young and passionate woman. I do not mean to say that my attitude
in regard to slavery has changed--that is the same, but when I think of
the awful results of the war to those who were dear to me, I have much to
be sorry for!"

(Signed) J.T.Dent

copied Feb.4,1960
by Margaret Davis Cate
exactly as written

AN APOLOGY. When the daughter of Fanny Kemble returned to Butler Island to help her father try to bring the plantation back following the Civil War, she too, like her famous actress mother, kept a journal. James Dent knew both mother and daughter as his letter indicates. Kemble's book published in 1863 as *Journal of a Residence on a Georgian Plantation 1838–39* caused much consternation. The South had counted on England for financial support, but none was forthcoming once Kemble's book was published. Though only in Georgia for four months, the record of Kemble's stay has echoed through the years. Kemble did note that the first ruins she had seen in all of America were at Fort Frederica on the north end of St. Simons Island, abandoned once the British left. Butler's grandfather was a signer of the Constitution from South Carolina. (Courtesy National Park Service, Fort Frederica National Monument, Georgia Historical Society, the Margaret Davis Cate Collection, 997.)

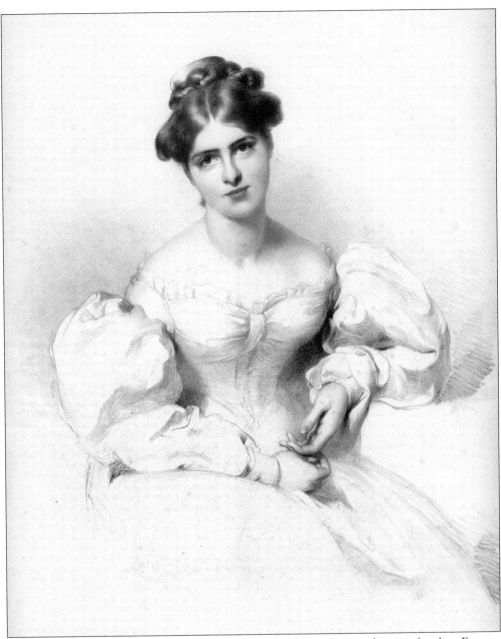

HER ETHEREAL BEAUTY. A member of one of England's most famous thespian families, Frances Anne "Fanny" Kemble became the toast of two continents. In Philadelphia, she met Pierce Butler and married him. When they came to the Georgia coast to visit his immense holdings, she brought with her their two young girls. Moved by the wild beauty of the area, Kemble recorded all she saw. Very active, she rowed across the river to Darien in her small boat she called the *Dolphin*. Estranged from her daughters by her divorce from Pierce Butler, Kemble maintained friendships along the Altamaha Delta. She was impressed with the courtliness of John Couper and must have enjoyed the gentle demeanor of James Dent. Her grandson Owen Wister wrote *The Virginian* and visited at Hofwyl. (Painting by Richard James Lane, printed by Charles Joseph Hullmandel, courtesy of National Portrait Gallery, London, England.)

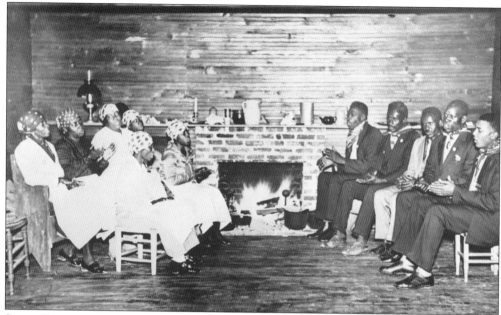

SONG CATCHER. Fascinated with the singing of old slave songs, Lydia Parrish, wife of artist Maxfield Parrish, began to record them. Many of the songs dated back to Africa. Organizing a group of singers, she built a cabin on her property where guests came to listen to the "sings." In 1942, Parrish published *Slave Songs of the Georgia Sea Islands.* (Courtesy of Georgia Archives, Vanishing Georgia Collection, gly060.)

RICE SONG. Both Cate and Parrish transcribed song lyrics. They each accorded the Dents much forethought in encouraging the people who worked at Hofwyl to share the old songs so they would not be lost. This rice song accompanied the use of the flail. (Courtesy National Park Service, Fort Frederica National Monument, Georgia Historical Society, the Margaret Davis Cate Collection, 997.)

They still do it the way here — Thank you for the lecture the other night. I recognized the card immediately — We are enjoying the trip very much — Our greetings — Thanks & Regards

Mrs. Margaret D. Cate
Sea Island
Georgia
U.S.A.

MAIL FROM TRINIDAD. A couple who had visited Sea Island sent this postcard to Cate. Few people realized the extent of rice cultivation on the Georgia coast. Rice was queen up until the 1850s. Other than songs that descendants might sing or the occasional plot of rice, little remained to suggest this period. (Courtesy National Park Service, Fort Frederica National Monument, Georgia Historical Society, the Margaret Davis Cate Collection, 997.)

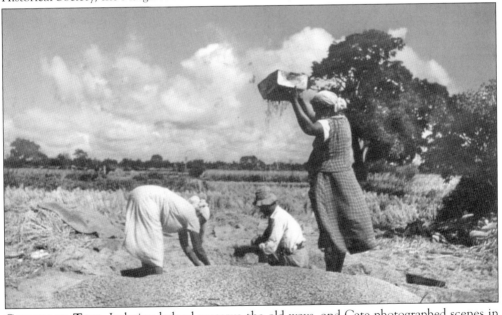

CAUGHT IN TIME. Isolation helped preserve the old ways, and Cate photographed scenes in Darien and on Sapelo Island like the one on the postcard. Hofwyl's last crop of rice was attempted around 1910. Flails, pestles, and rice baskets remain at Hofwyl-Broadfield to show how the crop was produced. (Courtesy National Park Service, Fort Frederica National Monument, Georgia Historical Society, the Margaret Davis Cate Collection, 997.)

THE ANNUAL MIGRATION. Requested to share some aspects of rice production, the two sisters penned a treatise, *The Rice-Bird in This Section*. These birds were often called the "May" birds, as they would dutifully arrive at a critical juncture in the rice-growing process and later in the summer. A flock could decimate a field, so everyone on the plantation old and young was drafted to thwart the descent of the hordes of marauding birds in any way possible. Pans were beaten and guns were used. Miriam Dent noted that she had questioned all who could remember the occurrence. Several other notes in the Cate collection by Miriam concern various people who had worked for their family for several generations. She noted that Fibby worked as a cook for 60 years at Hofwyl, working for three generations of the family. (Courtesy National Park Service, Fort Frederica National Monument, Georgia Historical Society, the Margaret Davis Cate Collection, 997.)

read at meeting of Savannah Historical Research Assn. Feb. 26, 1941 (read by Raiford J. Wood)

THE RICE-BIRD IN THIS SECTION

by Ophelia Dent

The small bird known as the Bobolink in the North, the Reed-bird along the Eastern shore, the Barley-bird in South America, and the May-bird on our Georgia Coast in May, turns into the Rice-bird on this same coast in late August.

It is as the very delicious Rice-bird that he is best known here, and because all rice-planting on a large scale has vanished from these parts, he, too, has vanished, and it is doubtful whether any of the younger generation has had, or ever will have the pleasure of tasting this small fat and juicy morsel.

However, it is not as food that they are remembered most by the rice planter himself, much as he may have enjoyed them on his table; but as a very real menace to the precious crop. These marauders were almost as destructive as a horde of locusts, unless the rice could be protected by bird-minders. Rice was planted from March 15th to April 15th, from the 1st to the 10th of May, and again for ten days in June. It was the June rice only that escaped the birds, for after feasting for two months on the March, April and May rice, they migrated to South America.

When the growing rice was tender, in "The Milk", or half green, they _sucked_ it swiftly, and, later, when cut, tied in sheaves, and stacked, the grain was hard and they had to _shell_ it, but the loss was just as great.

It was the habit of the rice-bird to reach the Georgia Coast almost on the same date, August 20th, year after year, knowing with unerring instinct that rice was beginning to ripen. The first birds, pale yellow and black, turning brown later, were rather easy to cope

DEFENDING THE CROP. The offensive bird that had acquired the name rice-bird was the bobolink. In her lectures, Cate showed a slide of it, describing the destruction that a flock could cause. The Dents in their three-page paper went on to admit that there was no tastier bird, as his gullet was full of rice, and that when they were cooked they were most succulent. Interestingly, the passenger pigeon is known to have eaten from the rice fields; one wonders if his demise may have been partly caused by forays into guarded rice fields. Rice crops were subject to other calamities. A freshet, a sudden flood of water from up country, could drown the fields. Even caterpillars could ruin a crop. (Courtesy National Park Service, Fort Frederica National Monument, Georgia Historical Society, the Margaret Davis Cate Collection, 997.)

Rice balls

called,Sarika, were made by Katie Brown's

grandmother,Margaret-daughter of the famous Bilaly,

to break the fast of a certain holy day.They were

not permitted to eat anything until the sun had set

Katie told me that they got the rice in Darien,

and her grandmother soaked it over night.In the

morning the rice was put in the mortar and pounded

with sugar until it became a paste. It was then

shaped into balls and placed on a fanner to dry.

Children were always served first.

An African booklet on Gold Coast Food,gives a sim-

ilar receipe except it is called:Fula. The rice is

crushed in a mortar and is then cooked in a very

little water,stirring all the time.Pepper,ginger

and various kinds of crushed seeds are stirred in

and the mass is made into balls and rolled in rice

flour. Hausas and Fulanis sometimes take fula with

milk although milk is not in general use.

A FAMILY RECIPE. Lydia Parrish, in her meticulous manner, recorded how she found this particular recipe for using rice. She credited it to the family of Bu Allah, who was Thomas Spalding's overseer. The Dents may have known of a similar recipe, as those who worked at Hofwyl may have also made the delicacy. The sisters were themselves always interested in cooking. They cherished the recipes of their mother. For them, rice was a staple, whereas in other parts of Georgia away from the coast, families might have preferred potatoes. Some coastal families had rice at least once a day. In a seminar in 1986 entitled "Man in His Landscape," Dent's thoughts about the cultivation of rice were read as part of the program. One of her fervent wishes was that rice one day might once again be grown on the Georgia coast. (Courtesy National Park Service, Fort Frederica National Monument, Georgia Historical Society, the Margaret Davis Cate Collection, 997.)

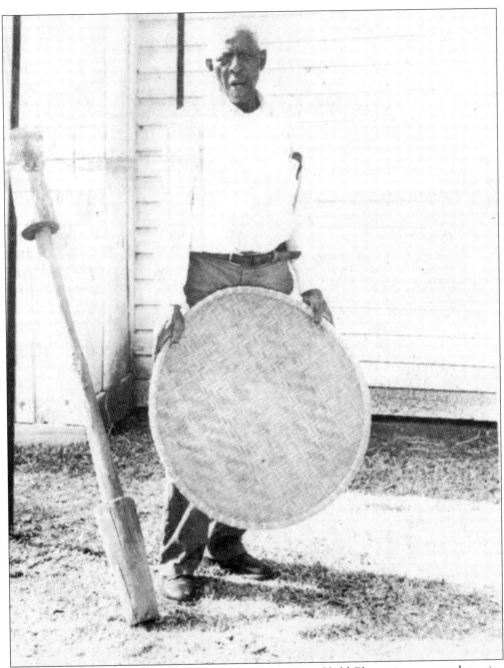

KEEPER OF THE PESTLE. Early programs at Hofwyl-Broadfield Plantation centered on rice cultivation where Rudolph Capers shared his knowledge. Attending visitors were used to buying rice in a box or bag. Just watching the labor-intensive process of taking the rice from the husk reminded them of how much mechanization had achieved. (Courtesy of Mickey Harrison, the *Brunswick News*.)

DECOR WITH A PAST. Used as kitchen decor in a Darien home, a rice basket and rice hook were used in the rice harvest. Basket making using marsh grass was yet another byproduct of rice production. Today these sweetgrass baskets are highly collectible; Yvonne Grovner of Sapelo Island is one of a few in the area who practice the art. (Courtesy of Billy Bolin, photograph by the author.)

Seven

THE LEGACY OF HOFWYL-BROADFIELD

A SENSE OF PLACE.
Ophelia Dent bequeathed
more than just land and
an "old barn of a house" to
the State of Georgia. She
passed on the legacy of a
sense of place. For within
that 1,268 acres were
the lives and aspirations
of many people. Not
just owners but also the
workers through the years
returned to Hofwyl and felt
it was part of their lives.
When each sister died,
before burial in Savannah,
services were held there
on the grounds with
family friends and devoted
employees. Standing under
the oaks and feeling the
marsh breeze, friends of
Hofwyl have always known
that it is a special place.
("Hofwyl Oaks," courtesy
of Albert Fendig Jr.)

IN THE QUIETNESS OF THE TREES. Ten miles north of Brunswick, Hofwyl-Broadfield's gates welcome all that choose to stop. The traffic noise from nearby Interstate 95 dissipates as one enters Hofwyl's tranquility. The naturalness of the area is part of the experience. For tree lovers, Hofwyl offers a variety. A great oak might topple doing a storm, but survive the fall and flourish. The Miriam Dent and Ophelia live oaks are members of the Live Oak Society. Meeting all requirements for membership, they are a reminder of the beauty of Georgia's state tree. Because of the tranquility, birds find Hofwyl a sanctuary, and birding programs are annual events. (Above photograph by the author; below photograph by Kathy Stratton.)

TRACES OF FAMILY. In the Visitors' Center, a series of trunks line the wall. Stenciled letters identify the owners. Once they were loaded upon ships for travel in this country and abroad. In the 1870s, the Cohens traveled to England. Records of expenses, carefully noted by Solomon Cohen, give a day's guide to purchases. The ephemera that make up the Howell Archives are staggering. Microfilmed in the 1982, the collection takes in all aspects of various families. The note below was found as Miriam Dent considered herself cleaning out the attic so no one else would have to do it. Fortunately for historians, much was saved. (Photograph by the author; letter courtesy of the Georgia Historical Society, MS 1288 Meldrim family papers, Box 3, folder 25, Georgia Historical Society, Savannah, Georgia.)

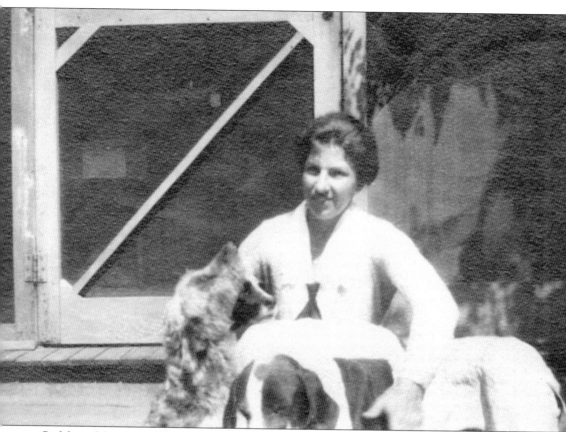

So Many Memories. The sense and presence of the Dents seems real to those who have worked at Hofwyl for a while. The memorabilia, the books, the china, the silver all speak volumes about the family. Old fans lined along the wall represent hot summer days on the coast. Well-worn boards of the flooring echo as visitors walk through the house. And in letters and records saved by family and friends and archived by the state, the sense of the two sisters, their personalities, their likes and their dislikes live. Above all is the great love both sisters had for their canine friends. A poignant letter of Ophelia's records the death of one of her favorite dogs, Black Boy. "He spent his last evening in front of the fire as usual, and had his head on my foot most of the time, and I just couldn't believe it was going to be the last time." (Courtesy of Arabella Cleveland Young.)

SAVANNAH REVISITED. Letters and records suggest that the Dents never lost their Savannah ties. Their family roots were deep. Fortunate visitors who chance to spend the night at 128 West Liberty at the Steven Williams Bed and Breakfast return to the Dents' family home. Winner of a preservation reward, the bed and breakfast contrasts greatly with Hofwyl's simplicity. On nearby Monterey Square, Temple Mickve Israel towers. The year 2008 marks the 275th anniversary of the arrival of Savannah's first Jewish families. Inside the temple, Solomon Cohen's years of dedication to the synagogue are inscribed. Rabbi Saul Jacob Rubin's book *Third to None* records the temple's history and tells much about the Cohen family. (Photographs by Cesar Ito.)

SAVANNAH GIFTED. Caring as she did about preserving her own home and land, Ophelia Dent's interest extended to entities in her natal city. In one letter, she decried the willful destroying of homes: "Will Savannah continue to destroy its beautiful old houses! ! ! !" Her will specified an amount for the Telfair Academy for Arts and Science. She also gifted her "seahorse mirror" to the body. The 2007 Artful Table Southern Style fund-raiser, presented by Telfair Academy Guild, used the mirror as its icon for invitations and publicity. Part of the funds from the benefit helped underwrite the restoration of a room in the Owens-Thomas House. Ophelia's family mirror hangs there in the dining room. Provenance on the mirror does not identify the maker. Dated c. 1815–1825, the girandole mirror could have been made in England or in the United States. It measures 36.5 by 27 by 7.25 inches. (Courtesy of Telfair Museum of Art, Savannah, Georgia. Gift of Miss Ophelia Dent, OT1954.6.)

A SENSE OF TRADITION. Visiting with Dr. Albert Galin and the Dent sisters was the inspiration for Harriet Gilbert's collection of Canton china. Their knowledge and love of this special china instilled in her the same appreciation. She, like others, found a welcome at Hofwyl, enjoying the intelligence and kindness of the sisters. Guides at Hofwyl-Broadfield note that shipments of Canton china provided ballast for clipper ships on the return passage to America. (Photograph by Karen Manning; courtesy of Harriet Gilbert.)

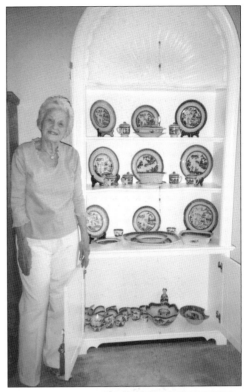

A REMEMBRANCE. Ophelia Dent's will detailed gifts to various friends, often telling where an item was located. This bequest to the daughter of one of her favorite friends combined the monograms of each sister. "OD" is monogrammed on the fine linen hand towel, whereas "MD" is engraved on the demitasse spoons. The spoons are English, c. 1750. (Photograph by Bobby Haven; courtesy of Arabella Cleveland Young.)

IMMEDIATE CARES. Preservation takes many avenues. Built at a time when interior walls were finished with plaster, the house has struggled with humidity-control problems in several of the upstairs rooms. Through the generosity of the Friends of Hofwyl, the plaster will be repaired. The gifting of the funds to begin work occurred at Hofwyl in the fall of 2007. Pictured from left to right are the new site manager Bill Giles; the new head of the Historic Site Division for the Department of Natural Resources, Frankie Mewborn; and Jim Bentley, former Friends of Hofwyl president. Earlier in 2007, the site lost one of its outstanding trees when winds toppled the second largest American holly in the United States. The grounds at Hofwyl require maintenance just as the house does. (Above photograph by Faye Cowart; below photograph by the author.)

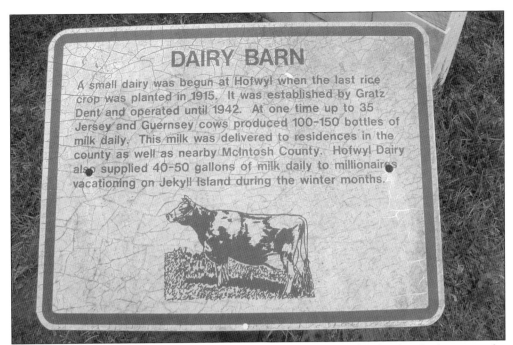

DAIRY BARN

A small dairy was begun at Hofwyl when the last rice crop was planted in 1915. It was established by Gratz Dent and operated until 1942. At one time up to 35 Jersey and Guernsey cows produced 100-150 bottles of milk daily. This milk was delivered to residences in the county as well as nearby McIntosh County. Hofwyl Dairy also supplied 40-50 gallons of milk daily to millionaires vacationing on Jekyll Island during the winter months.

A STORY TOLD. The state gave thought to selecting items to be highlighted with plaques on the grounds of Hofwyl. Visitors are encouraged to take a self-guided tour of the property and buildings. At one time, 35 Jersey and Guernsey cows grazed in the pasture. The dairy barn, the bottling house, and the pay shed reflect this period. Within the barn, much equipment is still there. Some of the oldest pieces date to the 1800s. Walking the fields of Hofwyl, a person realizes the size of the property. From the front yard, visitors can see Dent Creek, by which guests arriving would have come. The creek is an offshoot of the Altamaha River, where all commerce traveled before the advent of a highway. (Both photographs by Kathy Stratton.)

117

BEAUTY OF THE GARDEN. Both sisters reveled in their flowers. Letters tell of carefully packed boxes of gardenias sent north to friends. Faye Cowart, an interpretative ranger at Hofwyl-Broadfield for over 15 years has a fondness for the camellia garden. Her hope is to see the garden restored. Lloyd Flanders of Darien in *The American Camellia Yearbook 1969* wrote of two named varieties at Hofwyl. The Ophelia Dent, a pink semidouble, was originated by Miriam Dent and named for her sister. Another seedling which first bloomed on January 3, 1963, was named the Misses Dent for both sisters. That bloom was a small, semidouble pale pink. Plans detailing the original garden are available for its restoration. (Photograph by Bobby Haven, courtesy of the *Brunswick News*.)

Sudy —

A LOVE OF FLOWERS. In many letters, Ophelia would describe what flowers were blooming in her flower garden. She favored the wild garden types. "Lots of calendulas and still buds keep coming bowls of forget-me-nots, 2 or 3 Iceland poppies each day, lupin, cosmos and one or 2 Oriental poppies of a queer and beautiful shade." So many of the homes that she visited, such as Montpelier, where her friend Marion duPont Scott lived, or Longwood, where the Pierre du Ponts lived, had formal gardens. Dent would go and visit, but never seemed envious of what her friends had. She took delight in their extravagances and loved the symmetry of the formal gardens, yet delighted in the naturalness of her own surroundings. A wildflower garden is underway at Hofwyl, and once again a few blossoms may be placed in a simple milk bottle and set on a table. (Drawing courtesy of the author.)

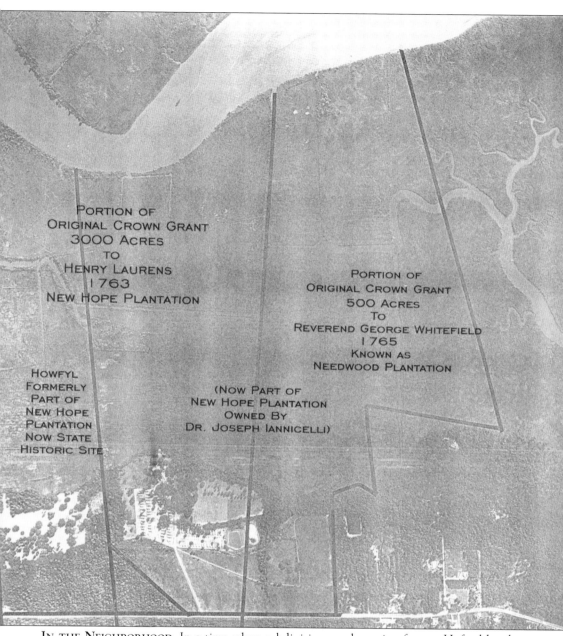

PORTION OF
ORIGINAL CROWN GRANT
3000 ACRES
TO
HENRY LAURENS
1763
NEW HOPE PLANTATION

PORTION OF
ORIGINAL CROWN GRANT
500 ACRES
TO
REVEREND GEORGE WHITEFIELD
1765
KNOWN AS
NEEDWOOD PLANTATION

HOWFYL
FORMERLY
PART OF
NEW HOPE
PLANTATION
NOW STATE
HISTORIC SITE

(NOW PART OF
NEW HOPE PLANTATION
OWNED BY
DR. JOSEPH IANNICELLI)

IN THE NEIGHBORHOOD. In a time when subdivisions replace pine forests, Hofwyl has been fortunate that the land surrounding it has not been developed yet. New Hope Plantation adjoins Hofwyl to the south. Owner Dr. Joe Iannicelli had a map created that shows the original land grant to Henry Laurens. To the south of New Hope was a plantation called Needwood, owned by the Rev. George Whiteside. The nearby African American community of Needwood may have taken its name from the plantation. Plans call for a renovation and additions to the home at New Hope, which was built in the 1920s. New Hope too was famous for its rice production and added to South Carolinian Henry Laurens's wealth. (Courtesy of Dr. Joe Iannicelli.)

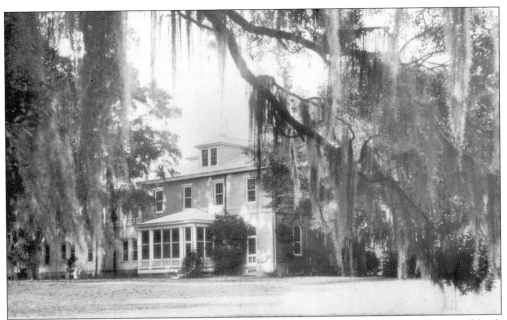

FRIENDS OF HOFWYL. When the Du Ponts bought Altama Plantation, the Dents visited back and forth with their friends. Years later, when it was sold, they maintained a friendship with the new owners, the Alfred Joneses of Sea Island. Like Hofwyl, Altama offers serenity with its large oaks and pines, its expanse of land, and closeness to the marsh and river. It was originally part of James Hamilton Couper's plantation, Hopeton. When young Jim Jones, grandson of the Joneses, worked at Hofwyl one summer, he painted a picture of the house, which now hangs in the Visitors' Center. Jones is now an accomplished New York artist known for his marsh scenes. He still returns to Sea Island and the Georgia coast to capture the beauty of its marshes. (Above photograph courtesy of the Sea Island Archives; below painting courtesy of Jim Jones.)

HISTORICAL INTEREST. The simple sign in front of Needwood Church tells the date of the church's beginnings. In recent years, renovation was done to the building, and a new state historic marker placed to give information about the community, which settled here after the Civil War. The small building off to the side was one of the last one-room schoolhouses in Glynn County. A nearby middle school was named Needwood in honor of the neighborhood. This section of Highway 17 has been designated a scenic highway. The Gullah-Geechee Corridor, which runs through four states, includes the Georgia coast. Its purpose is to document and tell of the African American experience. Those living in Needwood and Petersville are a rich resource for the history of African Americans. At a time when this neighborhood could have dissipated, it is still viable. It was some of these friends at Needwood that Ophelia Dent remembered in her will. (Photograph by the author.)

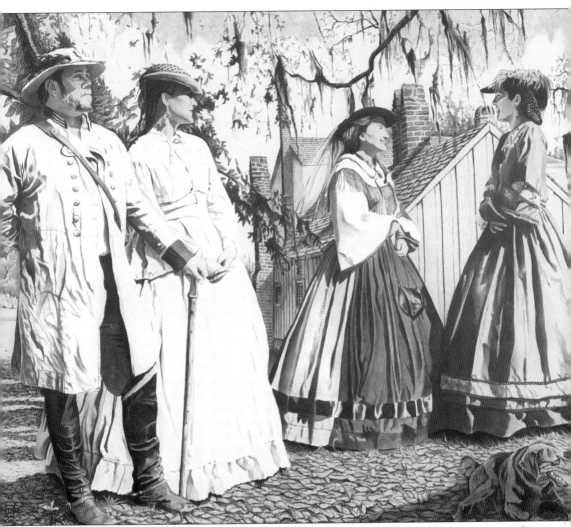

SUBJECTS FOR ART. William Temple, who portrays historical characters, also develops art around historic events. His painting *Hearth and Home Adieu* depicts the time in Ophelia Troup's life when the approach of war would signal removal in 1861 for the entire plantation to a refugee colony near Waycross. Capt. George Dent, Ophelia Troup Dent, and her cousins ready for departure. With the approaching 150th anniversary of the beginning of the American Civil War, interest will increase in events that were tied to local families. For several years, Confederate troop reenactments have been held at Hofwyl just as they have at Fort King George in Darien. The histories of so many of these Altamaha plantations overlap, each with a story well worth telling. (Courtesy of William Temple, Time Past Studio.)

PART OF THE HERITAGE. Ashantilly Center manages Ashantilly, once the home of the Bill Hayneses, who were the Dent's closest local friends. There always was an affinity with the Spalding lineage since the Dents, through their McGilvray and McIntosh connections, had Scottish ancestors and counted Spalding as kin. To raise interest in the property, several performances have been held where an audience enjoyed dialogue with the Spalding family. Bill Haynes hoped that Ashantilly could become a center for studying printing and other arts. The woodblock print below illustrates Haynes's talent. With the proximity of both Ashantilly and Fort King George, plans are underway for a Scottish celebration. Darien itself, founded by Scottish Highlanders who came with Gen. James Oglethorpe, were known for their superb fighting ability. All of the surrounding historical sites reinforce and expand the Hofwyl-Broadfield story, sharing the richness of the area and the unique families who chose to live there.

SHADOWS OF THE AFTERNOON. In the quietness of the piazza with the late afternoon sun shadowing the slanting wide-planked floor, a rocker sits solitarily. Many an afternoon, Ophelia and friends gathered here. The view from the porch took in the hovering trees and the surrounding outbuildings. Day ended with the sun sinking in the west, but in the setting of the sun, always a new day comes. The destiny of Hofwyl evolves, cherishing the past and interpreting what went before and looking ahead to new ways of telling the Hofwyl-Broadfield story. In a letter written in 1979, Patricia Carter Deveau of the Department of Natural Resources stated, "The theme for the program with be 'Hofwyl-Broadfield Plantation, 1803 to the Future' because we want to stress that a historic site's future direction is as important as its past." This maxim continues in the evolution of Hofwyl-Broadfield Plantation and in the interpretation of its families that loved this special place. (Photograph by the author.)

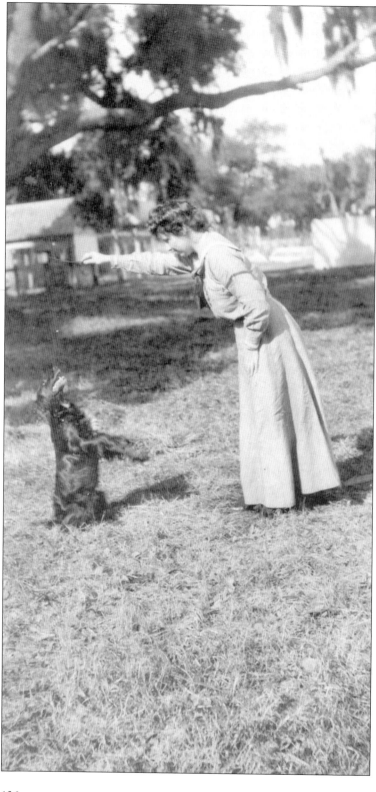

NEVER WEARY OF ITS CHARM. To look across the marsh, to walk the fields, or to drive through the gates of Hofwyl had to be some of the myriad images that sustained Ophelia Troup Dent and her love of the land. Her life centered on protecting the 1,268 acres she had inherited, keeping the rambling 1851 plantation-style house maintained, and deciding what would be Hofwyl's fate. For a person who had been a crack shot all of her life, she did not flinch from the responsibility of how to perpetuate what Hofwyl had meant to her and to her family. A detailed and dated note in 1959 listed the contents on the right side of the safe. After enumerating a few items, she noted, "Many other papers . . . All long ago affairs, but as I do not know their value I have held on to them." Fortunately, she held on the charm that was Hofwyl. (Courtesy of the Georgia Department of Natural Resources, Hofwyl-Broadfield Plantation State Historic Site.)

GOLDEN CAROLINA RICE. The rice plant has a delicate head that belies its strength as it anchors itself in the marsh muck. The various perils that it faced as it struggled to reach harvest mirrored the obstacles that the growers themselves and those who worked in the fields encountered. The institution of slavery made rice cultivation possible. In the lowlands of South Carolina and Georgia, the growing of rice came to end in the late 1800s. Ironically both cotton and rice, crops based on slave labor, ended on any large scale. Nowhere is the cycle of the crop illustrated as well as in the drawings of Alice R. Huger Smith Ravenel, which are collected in *A Carolina Rice Plantation of the Fifties*. To own the book is to hold an exquisite album of delicate watercolors that captures a lost era. The same tenacity that the rice plant exhibited serves as a symbol of those who held onto all they valued—the many different families who knew and loved Hofwyl-Broadfield Plantation through the years. ("Carolina Gold Rice," *c.* 1935, from *A Carolina Rice Plantation of the Fifties* by Alice Ravenel Huger Smith, watercolor on paper, Gibbes Museum of Art/ Carolina Art Association. 1958.09.01.)

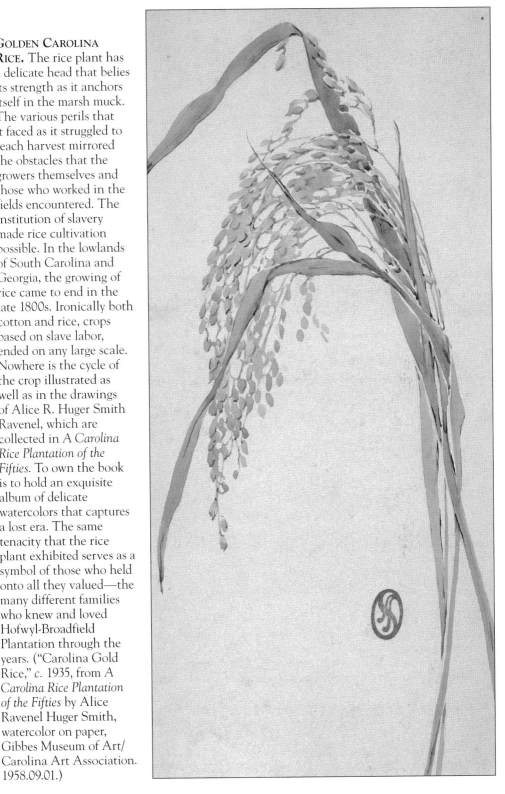

ACROSS AMERICA, PEOPLE ARE DISCOVERING SOMETHING WONDERFUL. *THEIR HERITAGE.*

Arcadia Publishing is the leading local history publisher in the United States. With more than 4,000 titles in print and hundreds of new titles released every year, Arcadia has extensive specialized experience chronicling the history of communities and celebrating America's hidden stories, bringing to life the people, places, and events from the past. To discover the history of other communities across the nation, please visit:

www.arcadiapublishing.com

Customized search tools allow you to find regional history books about the town where you grew up, the cities where your friends and family live, the town where your parents met, or even that retirement spot you've been dreaming about.